SWALE VILLAGES
THROUGH TIME
John Clancy

AMBERLEY PUBLISHING

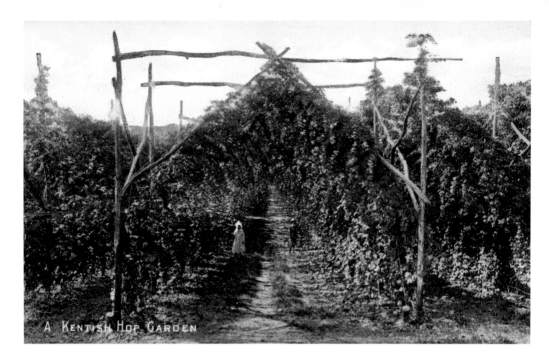

A Kentish Hop Garden

A Kentish Hop Garden

Kent was once well known for its hops. It has long been grown here, principally for producing home-brewed beer, which was safer to drink than water. There was an increase in hop growing in the second half of the eighteenth century, as the high price that could be demanded yielded a more advantageous return than fruit. Many orchards were subsequently dug up and hops planted in their place.

First published 2011

Amberley Publishing
The Hill, Stroud
Gloucestershire, GL5 4EP

www.amberley-books.com

Copyright © John Clancy, 2011

The right of John Clancy to be identified as the Author of this work has been asserted in accordance with the Copyrights, Designs and Patents Act 1988.

ISBN 978 1 84868 652 6

British Library Cataloguing in Publication Data.
A catalogue record for this book is available from the British Library.

Typeset in 9.5pt on 12pt Celeste.
Typesetting by Amberley Publishing.
Printed in the UK.

Introduction

Many parts of Britain are renowned for the 'chocolate box' quality of their pretty villages. Devon, the Cotswolds, the Yorkshire Dales, Suffolk and the Peak District immediately spring to mind, but never in the same breath do people include Swale in Kent. For the most part it's a delightful area that has long been known as the Garden of England, and hopefully the following pictures will show why.

Swale is the civic administrative district that stretches from Rainham in the west to Faversham in the east, Maidstone in the south and the Isle of Sheppey in the north, covering an area of some 280 square miles. It originated as the Anglo-Saxon territorial area of the Manor and Hundred of Milton, and takes its name from an arm of the sea to the north that separates the Isle of Sheppey from mainland Kent.

In the mid-nineteenth century, the railway came to this part of Kent, closely following the line of Watling Street, offering an even faster journey time to the capital, which was ideal for the agricultural market. Because of the topography of the land – Swale being located on the gentle downhill northern slope of the North Downs – all major transport links run east–west. This made Sittingbourne and Faversham ideal distribution centres for the outlying villages in getting their wares and produce to market.

This book highlights many of the small villages, hamlets and settlements that are scattered throughout this area, which was once renowned for its diverse agricultural practices. Nineteenth-

century census returns clearly show that agriculture was the main occupation of those who lived in these villages and, as will be seen, many of the names of these villages reflect their earlier agricultural heritage. The immense number of orchards for which Kent is famed led to the founding of Dean's jam factory, in Sittingbourne, where the surplus fruit was made into jam. Similarly, this area once had many hop fields and the hops were processed into beer at the Shepherd Neame brewery in Faversham. As will be seen in the following collection of old and new pictures, this way of life is fast disappearing, along with the traditions of village life.

The town of Sittingbourne was well known for its industries of paper making, brick making and cement manufacturing. These trades lured many agricultural workers with the promise of higher wages, leading to a sharp decline in agriculture in the nineteenth century. It was similarly so in Faversham. These commodities, along with agricultural produce, were imported and exported all over the UK and the Continent by the distinctive Thames spritsail sailing barges based in the ports of Sittingbourne, Milton Regis and Faversham. Despite its industrial heritage, Sittingbourne retained important links with the agricultural world by having a cattle market and a corn exchange. But due to the consolidation of the price of corn around 1880, many corn exchanges closed down, and Sittingbourne's became the town hall. Another industry linked with the local agrarian economy was the way in which the sailing barges took bricks, cement, etc. to London and, rather than return empty, filled up with the capital's waste material for the return journey. The manure and straw from the stables were offered to farmers, while all other rubbish, known locally as 'rough stuff', was used to help fire the bricks being made in the brickfields.

As we move through the early twenty-first century, Swale's villages, like others all over the country, are but a shadow of their former selves. Changing agricultural practices have greatly affected the number of people involved in farming. Villagers now commute to the larger towns to work, while incomers have moved into empty accommodation to sample country living. A

taste of how country life used to be is captured in old postcards and pictures, but when compared with modern-day views, the reality really starts to kick in. A constant problem encountered while trying to locate the early postcard photographers' viewpoints is that the ever-growing trees and shrubbery now mask many views. Elsewhere, housing development has obscured old vistas. Despite this, every effort has been made to reproduce those early views, but if some seem to appear 'not quite right', this is the reason why.

Brief mention should be made of a notable omission from this book. The villages and hamlets located on the Isle of Sheppey, itself an integral part of Swale, will be included in the forthcoming *Isle of Sheppey Through Time.*

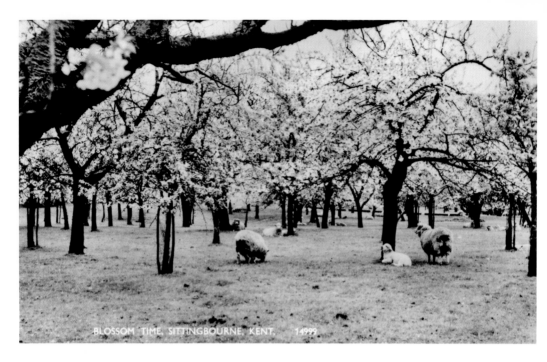

BLOSSOM TIME, SITTINGBOURNE, KENT. 14999

An Unending Sea of Blossom

For many centuries much of Swale was covered by apple and cherry orchards. It was the oldest of the five major fruit-growing districts of Kent, dating back to the reign of Henry VIII. While some of our fruit crop would have been consumed locally, much was taken to London and other cities. Sheep were brought in from time to time to keep the grass down. Typically though, as seen here from the top of Newington's parish church, it was an unending vista of orchards. In the centre of the picture is that quintessentially Kentish building, an oast house, originally used to dry hops.

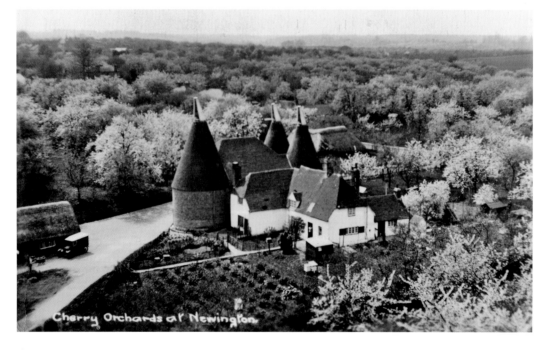

Cherry Orchards at Newington

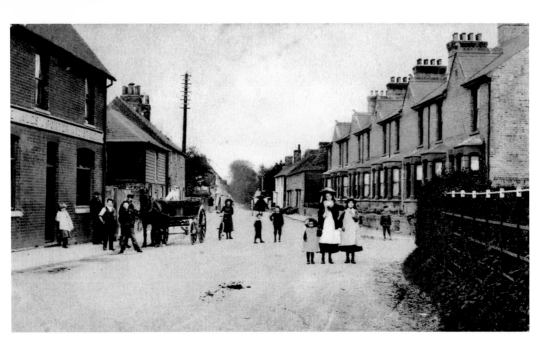

The Street, Bapchild

Situated on the A2 road just a few miles to the east of Sittingbourne, Bapchild is said to be one of the oldest settlements hereabouts, known in AD 694 as Beccancelde. It was there that the Great Council of the Anglo-Saxon Heptarchy met, which was summoned by and presided over by Wihtred, the King of Kent and Brightwald, the Archbishop of Canterbury, then styled as the Archbishop of Britain. This meeting was also known as the Witangemot, the equivalent of today's Parliament, but dealing with both secular and ecclesiastical matters.

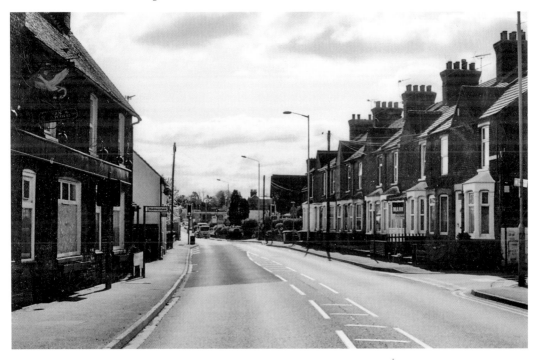

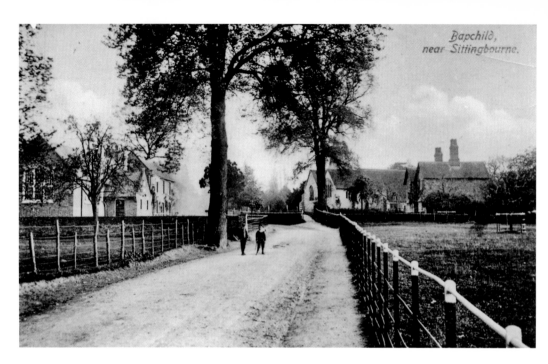

The Village School, Bapchild

Unlike many of its contemporaries, Bapchild still has a village school, situated in School Lane. At first there were two small schools located in private cottages at opposite ends of the village, but in 1852 it was decided to replace them with the present school. Throughout its history it has been a Church Aided Foundation, and until recently the incumbent head teacher lived continuously at School House, which must be a unique record in public education.

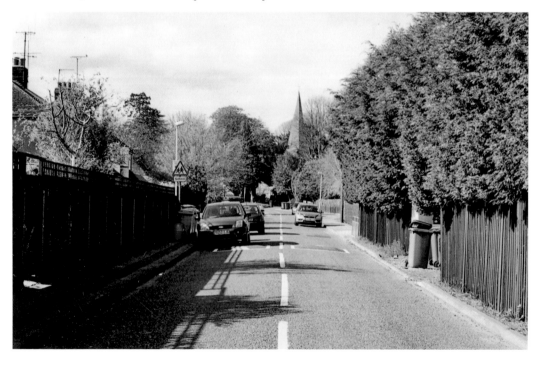

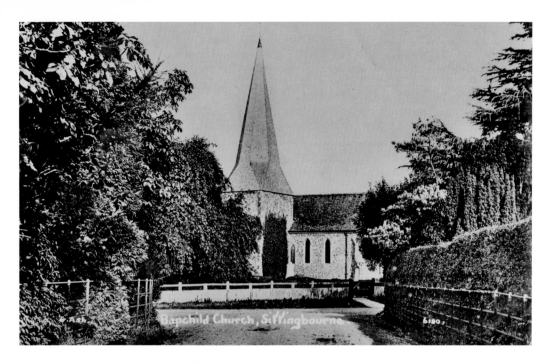

St Laurence Church, Bapchild

Further along School Lane is the eleventh-century parish church dedicated to St Laurence. The church was built using locally sourced materials such as flint and chalk, which can be seen in the nave with its fine chalk columns. Early English builders added the aisle and long, narrow chancel. The tower and spire date from the thirteenth century, while the porch is of Tudor origin. The earlier fine view has now been masked by that blight on the landscape, Leylandii trees.

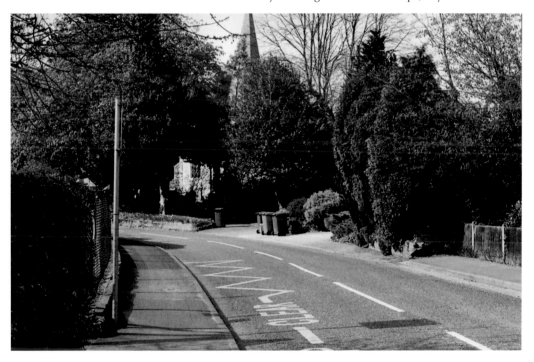

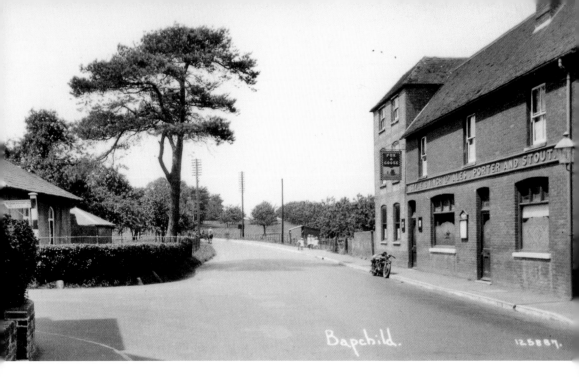

The Village Pub, The Fox & Goose

Looking westwards along the street, towards Sittingbourne, is Bapchild's last remaining pub, the Fox & Goose. Although the first picture looks idyllic, the street is actually the A2, an extremely busy road.

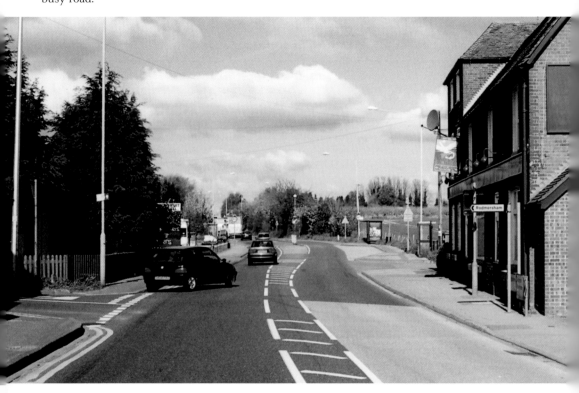

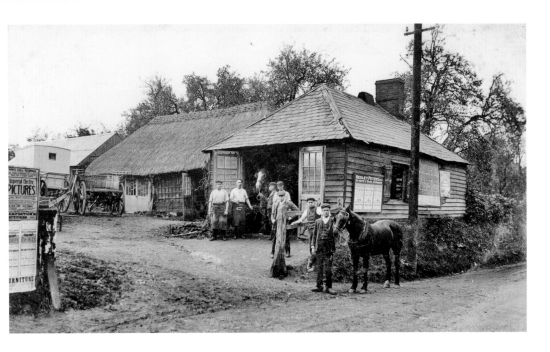

The Village Smithy

When I purchased the top postcard I was told it showed a forge in Murston. I knew the location well and could see it in my mind's eye. But when I showed it to a noted Murston historian, he pointed out it was not Murston's forge but that of Bapchild. How time can play tricks on you. Further research revealed the picture is of Mr James Terry, Bapchild's blacksmith and wheelwright, whose forge stood where today there is a garage. The picture was taken in around 1920.

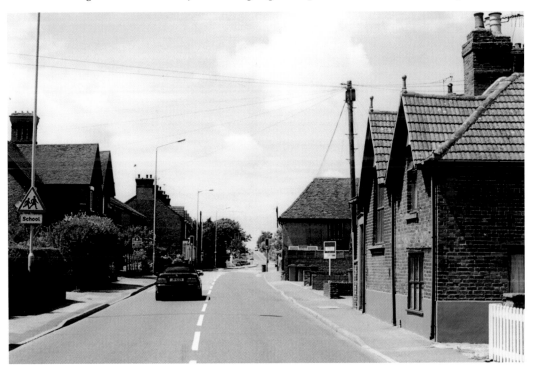

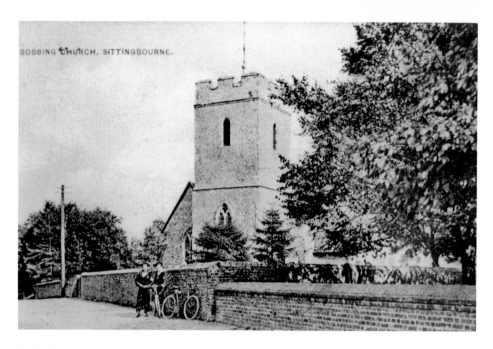

BOBBING CHURCH, SITTINGBOURNE.

St Bartholomew's Church, Bobbing

Bobbing lies just off the A2 on the A249 Sheerness–Maidstone road. It is one of those strange little villages that, despite having a church and a school, has little else. The parish church is dedicated to St Bartholomew. It is thought that the oldest part of the church is the north aisle where the organ stands, probably built between 1234 and 1250. The main part of the church was added in the fourteenth century. The tower was once capped by a tall steeple, according to a painting of Bobbing in 1807, but it is unclear when and why it was removed – or even if it ever existed.

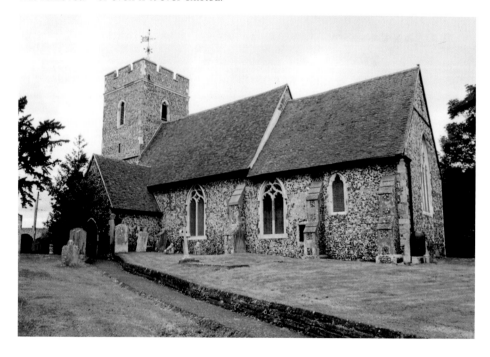

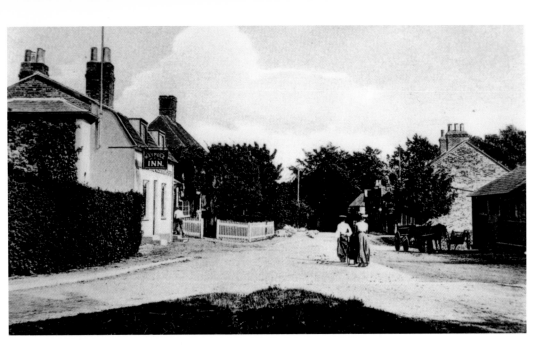

The Maypole at Borden

Borden is situated to the south-west of Sittingbourne, from which it is separated by a small area of rural land; the locals have long resisted all attempts to join it to Sittingbourne, preferring their independence as a village. The village's name is thought to derive from *bor* meaning a hill and *denn* meaning a woodland pasture. It may also be conceivable that it derives from 'boar' and 'den', as it is known that these wild animals once frequented the surrounding areas. Borden was first recorded in the twelfth century as *Bordena*.

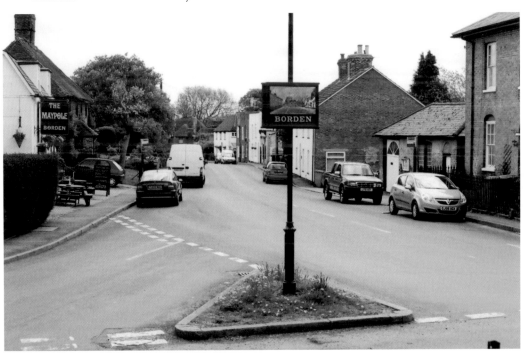

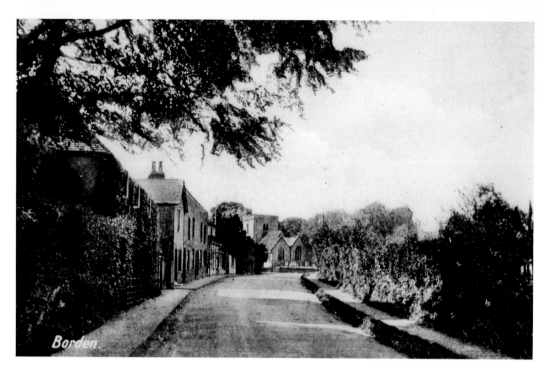

The Church of St Peter and Paul, Borden

The village is clustered around the church, which is dedicated to Saints Peter and Paul and is at least eight hundred years old. The village's Church of England primary school is considered to be one of the best in the county, after improving its reputation and teaching standards substantially over the last ten years. The local inn is The Maypole, which stands close to the church.

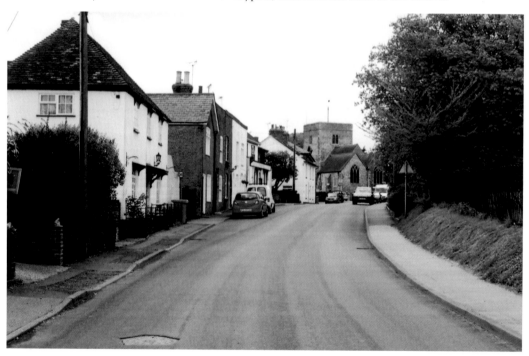

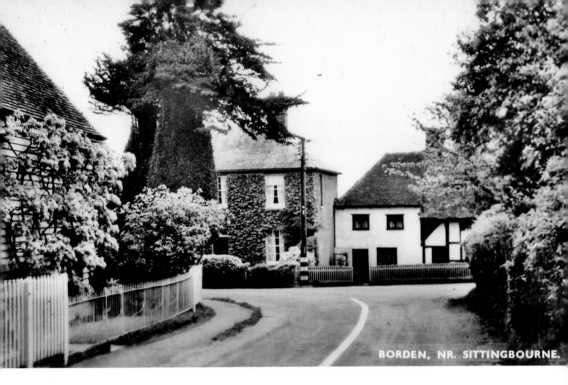

BORDEN, NR. SITTINGBOURNE.

Leaving Borden

Looking eastwards, back towards Sittingbourne, there are many picturesque architectural features in Borden. Thankfully, many of these have not been altered over the centuries and the village retains its rural, close-knit character.

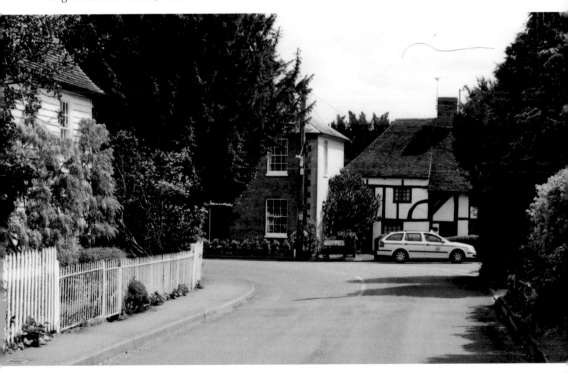

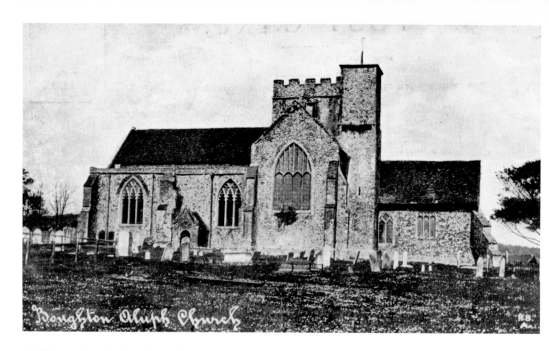

All Saints Church, Boughton Aluph

Located on the far eastern side of the Swale area, bordering Ashford and Canterbury, is Boughton Aluph, a name meaning a beech farmstead that originated in Anglo-Saxon times. The suffix 'Aluph' comes from Alulfus de Boctone, who gave his name to the village to distinguish it from other villages prefixed Boughton in the area. Boughton Aluph parish church dates from the thirteenth century and is dedicated to All Saints. As it is so close to one of the routes that pilgrims took to Canterbury, it is likely these pious souls would have visited the church.

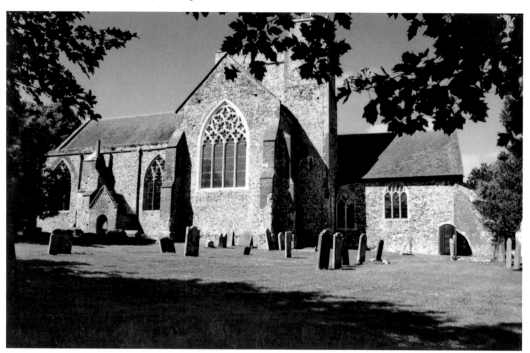

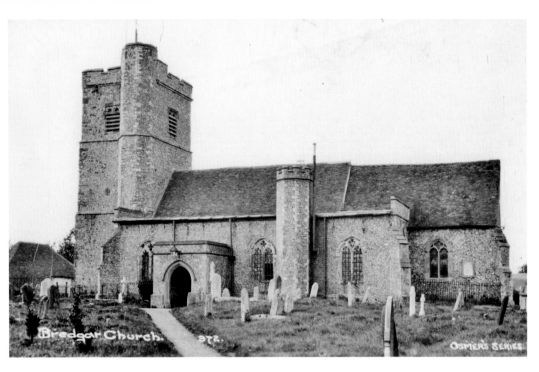

St John the Baptist Church, Bredgar

Bredgar is a pleasant little Downland village, clustered around its eleventh-century church, which is dedicated to St John the Baptist. Like many local village churches, it is built mostly of flint, a common-enough local building material.

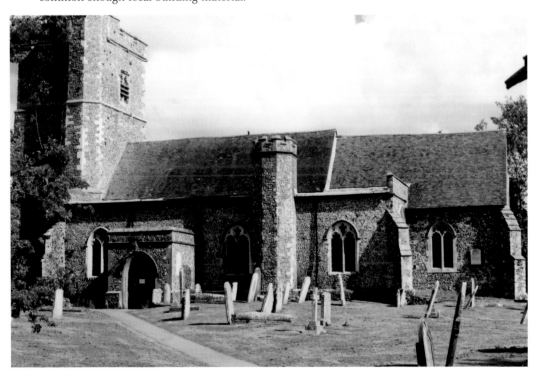

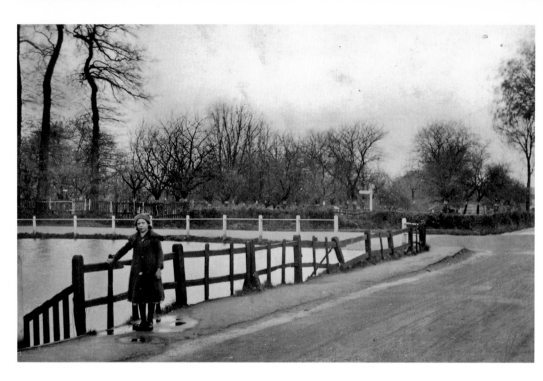

The Village Duck Pond, Bredgar

Situated in the middle of Bredgar is that quintessentially English village feature, the duck pond; not many villages still retain this. Behind the trees, and now the modern housing, is the College, founded by Robert de Bradegar in 1393. It has long been a private house.

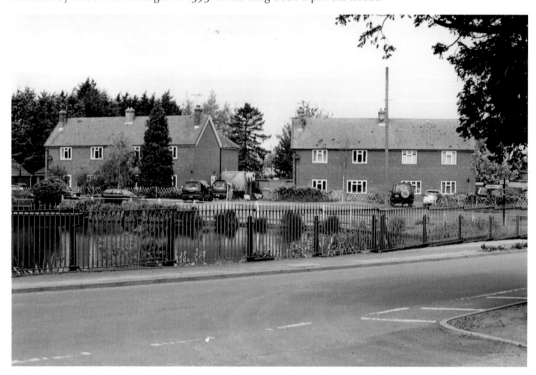

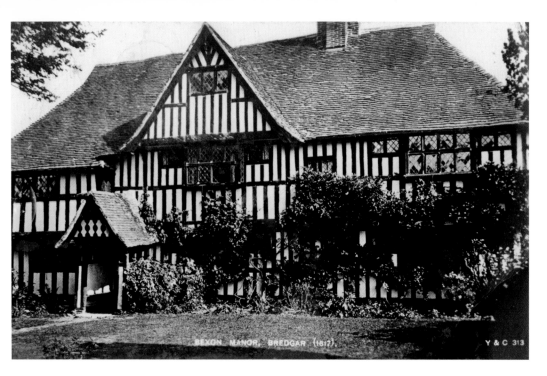

Bexon Manor House, Bredgar

Bexon Manor is a fine example of a Kentish Wealden hall house, and stands a short distance away from the village centre, at the heart of Bexon Manor Farm in Bexon Lane. Originally built in the fifteenth century, it underwent a certain amount of alteration in 1617.

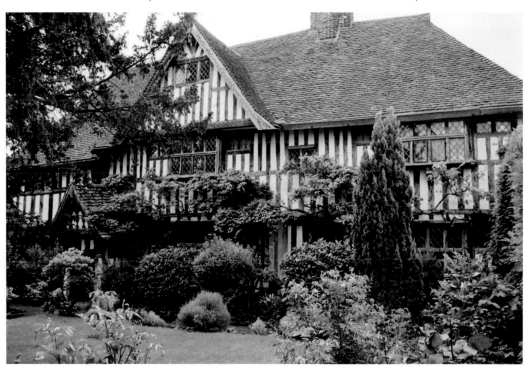

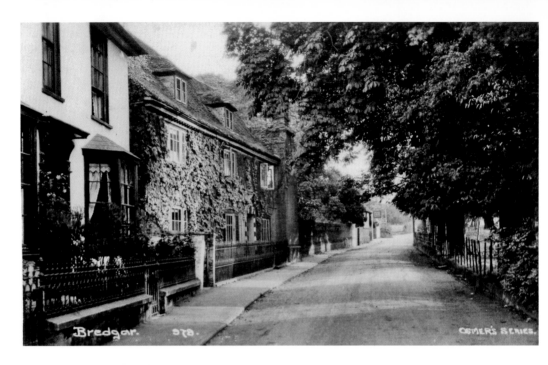

A Southern View of Bredgar

As one looks southwards along the main road to Hollingbourne, Brickwall is a village-centre house that dates to the mid-sixteenth century, with some additions made in the 1930s. It is a typical Kentish farmhouse in style and it is said that cows were once kept here, where a modern bungalow now stands. The cows were watered in a pond by the back gate of Brickwall, but it has long since dried up.

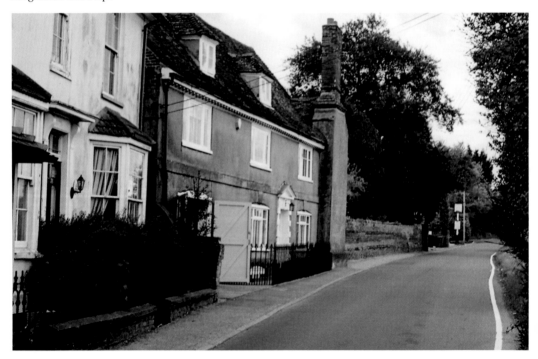

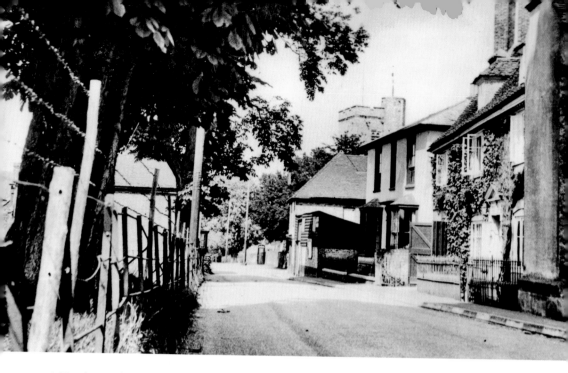

A Northern View of Bredgar
Much the same view of Brickwall, only looking northwards towards the church.

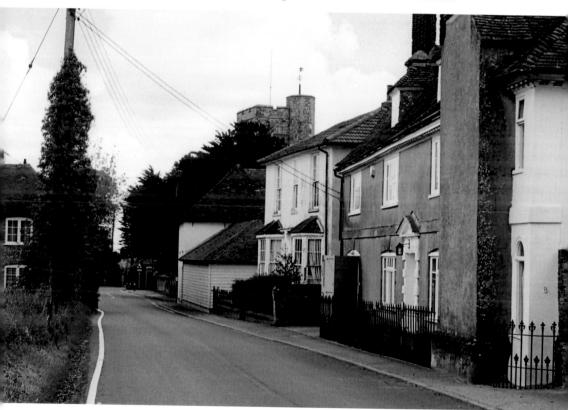

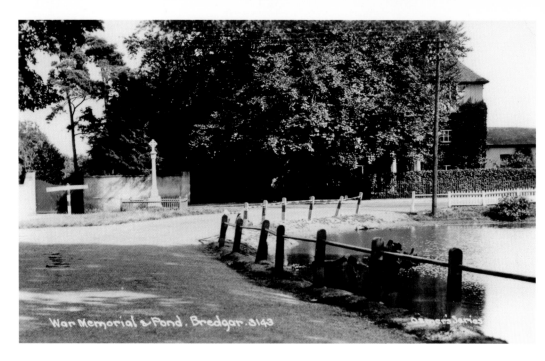

Bredgar War Memorial

The war memorial and Bredgar House, looking east from Gore Road. The truncated concrete cones by the war memorial are wartime tank traps. Bredgar House was purchased in 1867 by a wholesale ironmonger and brass founder from London called Comyn Ching, who had such a large family that he raised the roof and added a third storey to house them all. His company, which supplied the railings for London's Royal Parks, is still going strong with a Comyn Ching still at the helm.

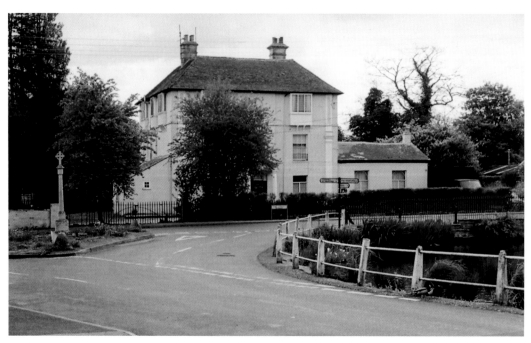

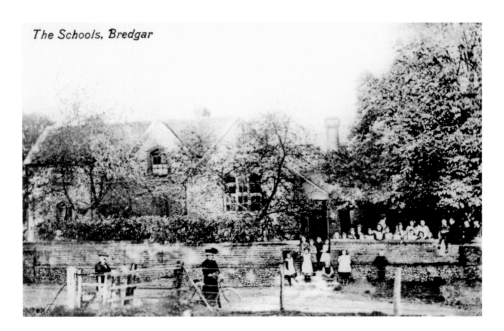

The Schools, Bredgar

The Village School

Bredgar C of E Primary School (Aided). The decision to apply for permission to build a village school was made in July 1868. A specially formed committee approached the Charity Commissioners, who granted permission for the school to be built on a plot of land next to the churchyard and additional land was purchased from adjoining landowners. Work commenced in the following year and the school was then opened. Parents paid 3*d* per week for their first child to attend school or 2*d* per week if they had more than one. Anyone who fell into arrears was discharged. In the early days of the school, the girls were expected to sweep and dust the building.

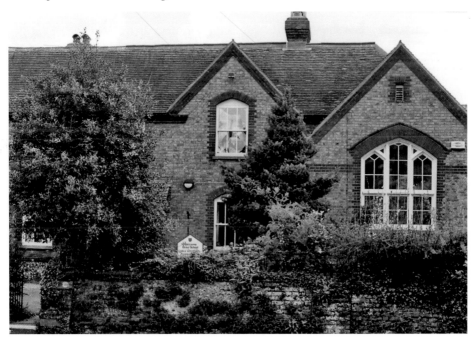

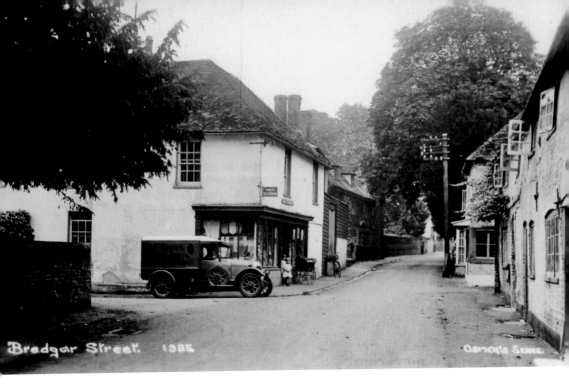

The Village Post Office

Looking south along the village's main thoroughfare, The Street. To the left is Bexon Lane, with the former village post office and shop, now a private house, on the corner.

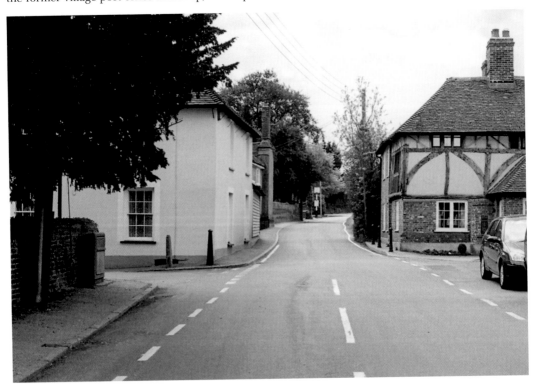

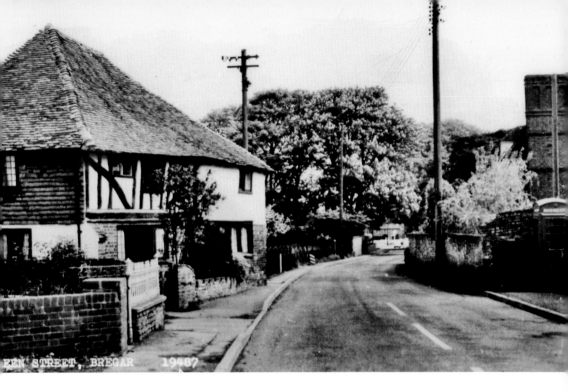

Green Street, Bredgar
Looking northwards along the main street. This must surely be one of Bredgar's oldest houses.

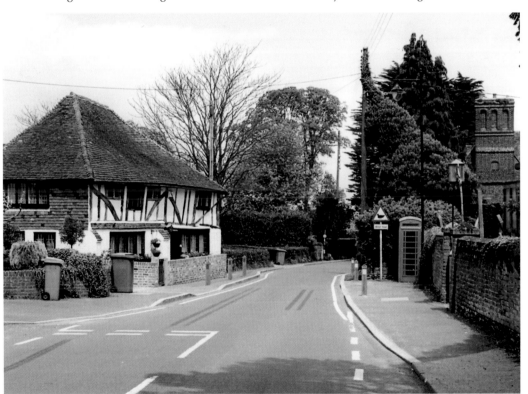

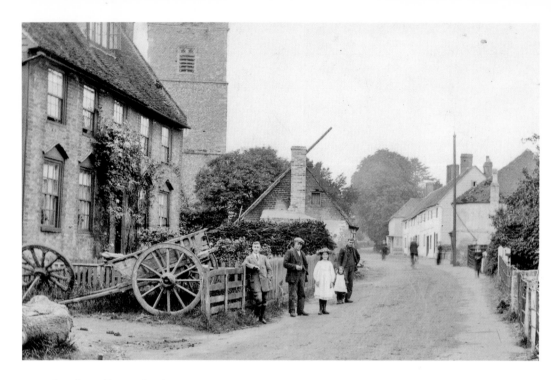

Burnham House, Bredgar

Burnham House has the appearance of being typically Georgian in style, but appearances can sometimes be deceptive! This fine old house actually dates back to the late medieval period. It was built around 1520 as the Priests' House for the Chantry College that once stood opposite. Following a disastrous fire in the early twentieth century, when the east wing was totally destroyed, Burnham House remained largely unrestored until 1980 when the then owners had the house reconstructed.

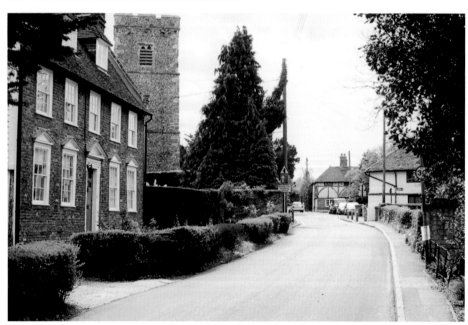

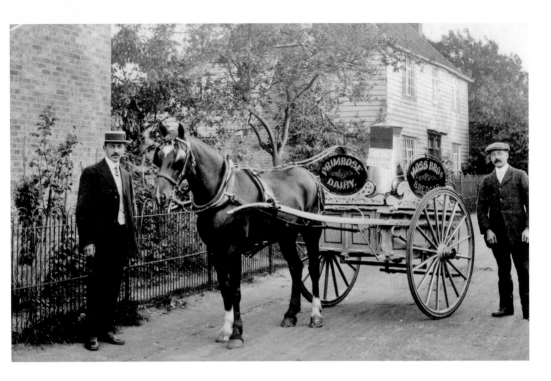

The Changing Face of Village Shopping

Once, milk and other dairy products were delivered door-to-door in and around the village by the Moss brothers from Primrose Dairy in a delightful pony and trap. Today, villagers gather in the village shop, built in a converted barn, where not only have they access to a wider range of goods, but they can also catch up on all the local gossip and news over a cup of tea.

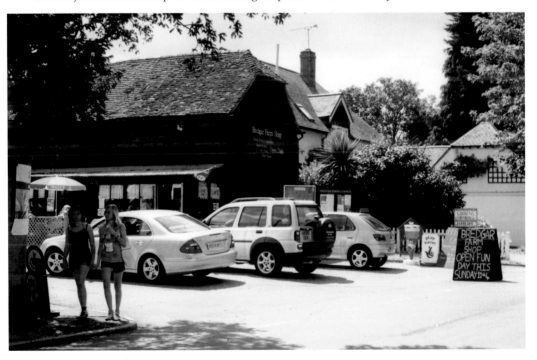

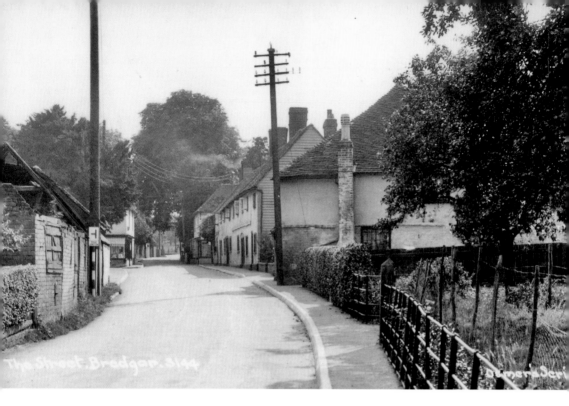

Looking Southwards along The Street

The Street, looking southwards towards the old post office on the corner of Bexon Lane. Today, the iron railings to the right of the early view have been replaced by a brick wall, the dilapidated shed by the telegraph pole has been demolished, and the large tree to the left of today's view hides the church.

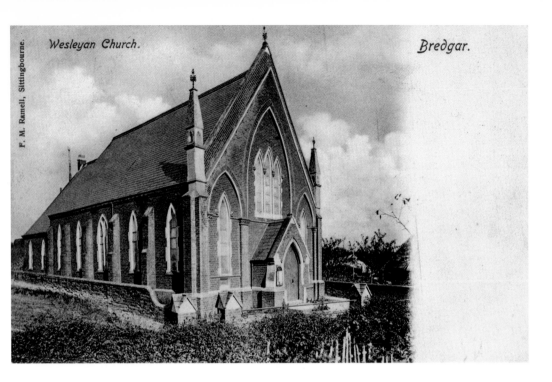

F. M. Ramell, Sittingbourne.

Wesleyan Church. Bredgar.

The Wesleyan Church

Non-conformism had a strong following, especially in the rural areas of Britain in the nineteenth century. Bredgar was no exception. In Silver Street the Wesleyans built this magnificent Gothic church in 1868. It even had a schoolroom attached. It succeeded a smaller, earlier chapel built in 1811. However, it was sold in 1930, demolished, and a new house eventually built on the site. Today, just a tantalising glimpse remains. Look carefully in the foliage in the front garden and you'll see one of the church's original gate pillars.

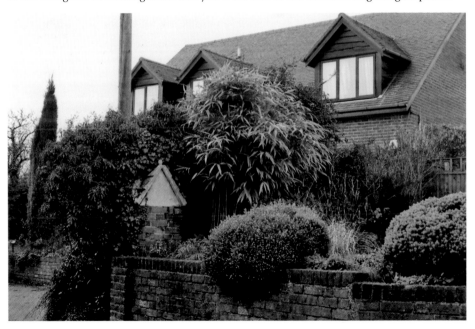

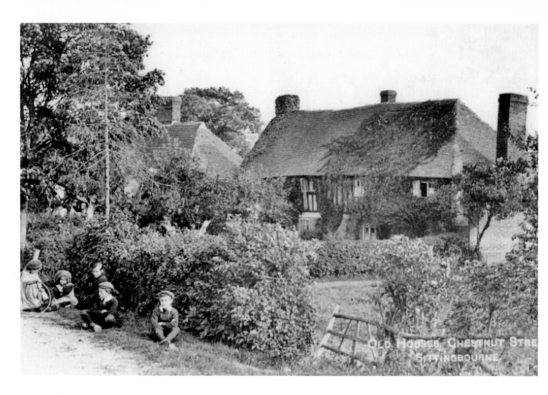

The Hidden Hamlet, Chestnut Street

Chestnut Street is a quaint little hamlet situated on the old A249 Key Street–Maidstone Road. I say 'old' because the road has been superseded by a new motorway-type of road, taking lorries from nearby Sittingbourne's industrial estates to the M2 motorway. Chestnut Street has thus been bypassed, but its pub, the Tudor Rose, is still a popular restaurant amongst locals. These Wealden hall houses are always an eye-catching sight when passing through.

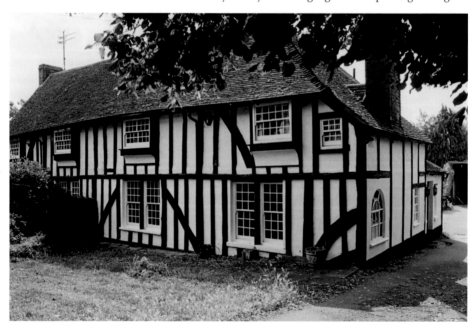

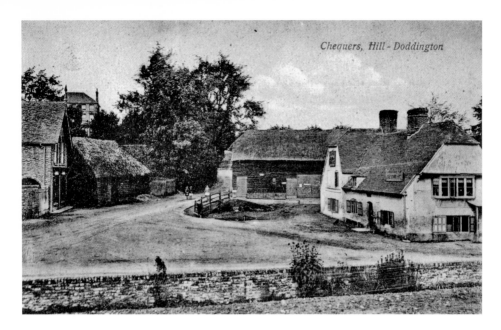

Chequers, Hill - Doddington

The Village Inn, Doddington

Doddington nestles in the Newnham Valley, just off the A2, midway between Sittingbourne and Faversham. At the heart of the village stands The Chequers, its local pub, a building that is thought to date back to at least the twelfth century. The church is dedicated to St John the Baptist and it is said that King Richard the Lionheart, while on his way back to London from the Holy Land, spent a night at The Chequers inn. He had with him a souvenir, a stone upon which John the Baptist was supposedly executed, and this gave the villagers the inspiration to so name their church. Fact or fanciful thinking – who can say for sure? This was not the village's only royal visit, however. In 1304, Edward I and Queen Eleanor stayed for a few days.

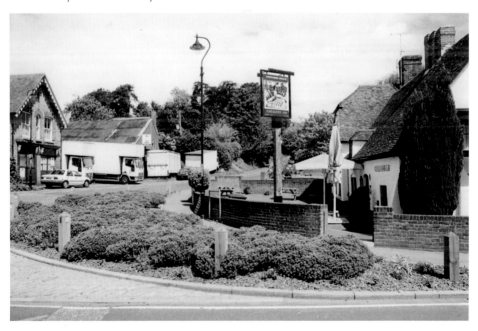

31

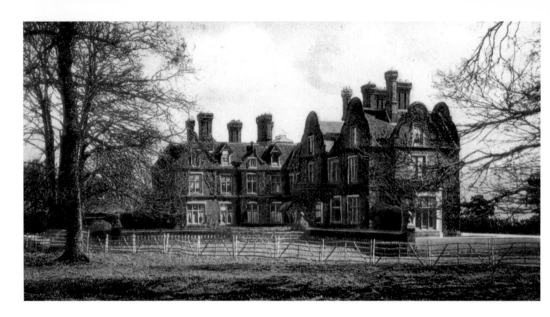

Doddington Place

The local 'big house' is Doddington Place, which has been the home of the Oldfield family for over a century. The many-gabled brick house was designed by the Victorian architect Charles Brown Trollope and built around 1860 for Sir John Croft of the port and sherry family. In 1906, the Crofts sold Doddington Place and the estate to General and Mrs Douglas Jeffreys. The latter was so impressed by the view that she claimed to have made up her mind before even setting foot inside the house. On the death of Mrs Jeffreys in 1954, her nephew John Oldfield inherited the house. His long life was full of variety – a Labour MP in 1929–31, the last survivor from that Parliament, and later he became Vice-Chairman of London County Council. He became a Conservative in the 1960s and was then a member of the Kent County Council for twenty-five years. In 1985, Mr and Mrs John Oldfield moved to the east wing of the house and handed over the running of the garden and estate to Richard Oldfield and his wife, Alexandra.

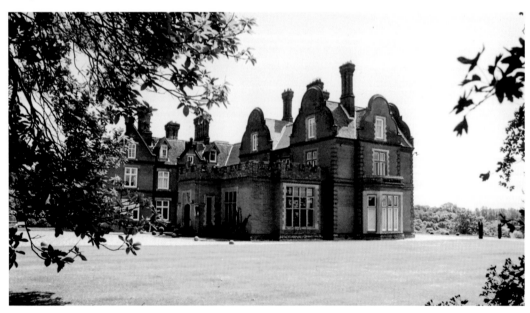

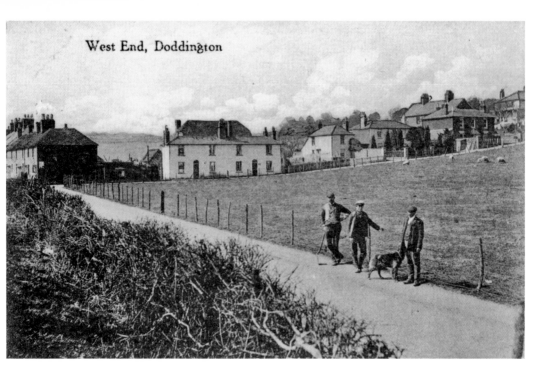

West End, Doddington

The Western End of the Village

The western end of the village of Doddington has undergone something of a transformation since the top picture was taken. The hillside houses of Dully Hill have been obscured by the trees, the white-painted house – once the workhouse – has been demolished and replaced by more modern housing, and where sheep once grazed are now houses and a playing field.

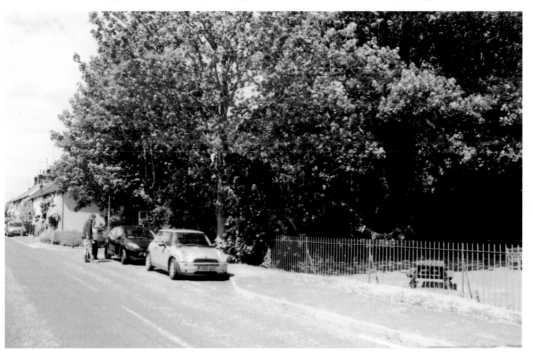

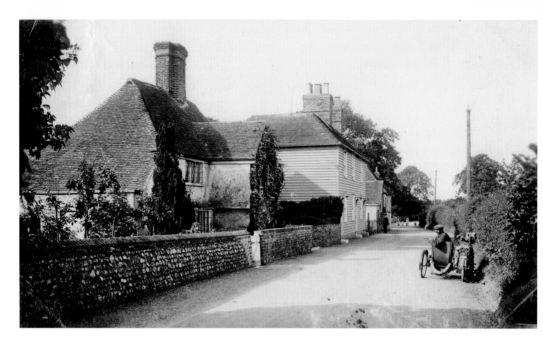

The Street, Eastling

It is generally accepted that the name Eastling derives from the name of the Jutish tribe of Eslingas who built a settlement in the area towards the end of the fifth century. The village lies 4½ miles south-west of Faversham, on the dip slope of the North Downs, 300 feet above sea level. Many of the buildings in the parish are listed, with several good examples of hall houses. Much of the village itself is in a protected Conservation Area. Here we see the garden wall of Porch House, and beyond are Kings Cottages and The Forge.

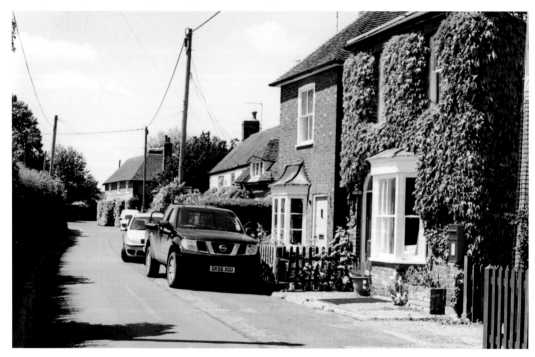

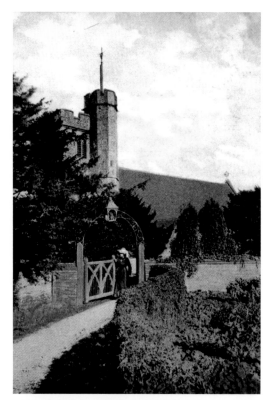

St Dunstan's Church, Frinsted
Frinsted's parish church is dedicated to
St Dunstan and dates from the twelfth
century. Its tower was enhanced in the
mid-nineteenth century by the addition of
a clock with chimes and five bells, a gift of
the then late Lord Kingsdown.

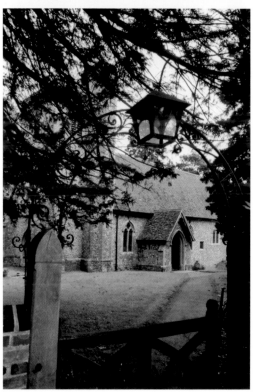

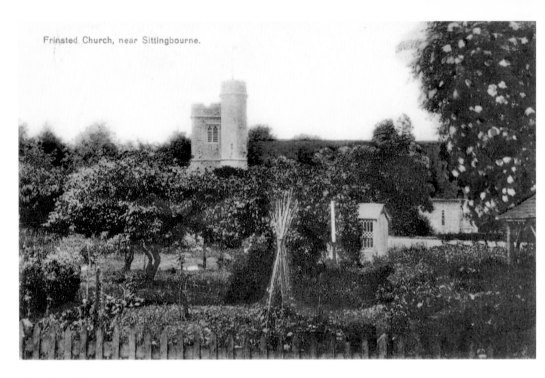

Frinsted Church, near Sittingbourne.

The Church in a Rose Garden
Another view of the church, only this time showing how it was set in a delightful rose garden, all traces of which have gone today.

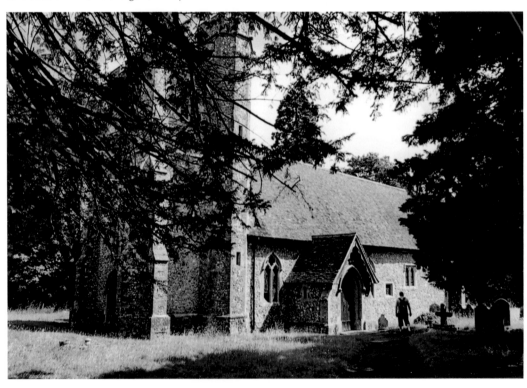

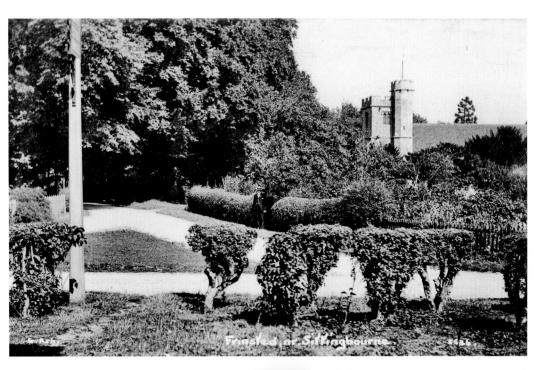

The Village Pub

The church, as seen from the front of the village pub – the Red Lion – whose sign can be seen to the left of the early view. Today, with so much rampant vegetation hiding the church, the viewpoint had to be realigned.

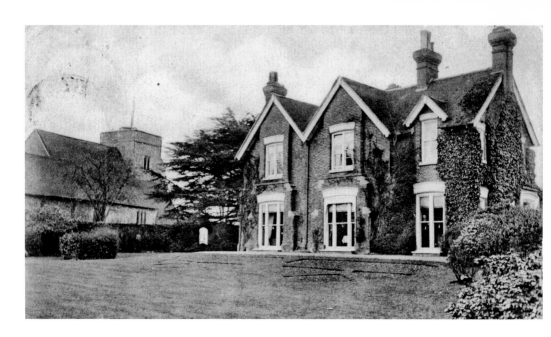

Hartlip Vicarage

Hartlip is a village situated about four miles to the west of Sittingbourne and a mile or so south of the main road, the A2. It probably originated in the time of the Anglo-Saxons, who called the settlement Hart Hlep, the leaping place of the hart or deer. There are many ancient names to be found in the parish in its fields, farms, houses and lanes. However, the roads in Hartlip that lead off the A2 are almost certain to be of Roman origin; a Roman villa was found in the southern part of the parish in 1733. Here we see the typical country vicarage standing next to its church.

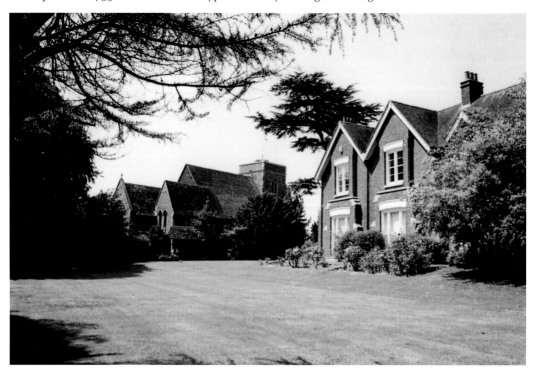

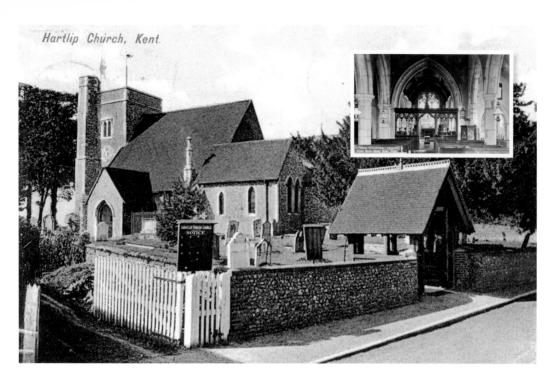

St Michael's and All Angels Church, Hartlip

Hartlip's parish church is dedicated to St Michael and All Angels, and stands in a prominent position so that it can be seen for many miles around. The earliest style to be seen today dates back to the latter part of the thirteenth century, but documentary evidence reveals the church dates from at least 1225. It was restored in 1845 under the direction of William Bland, one of the churchwardens, at a cost of £37 8s 6d.

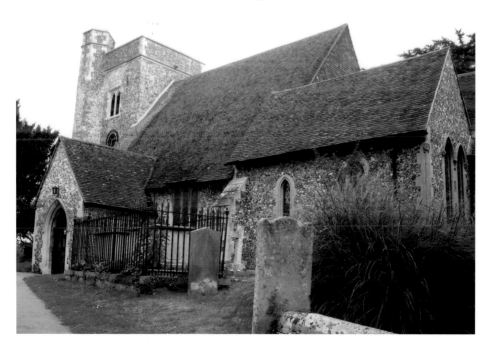

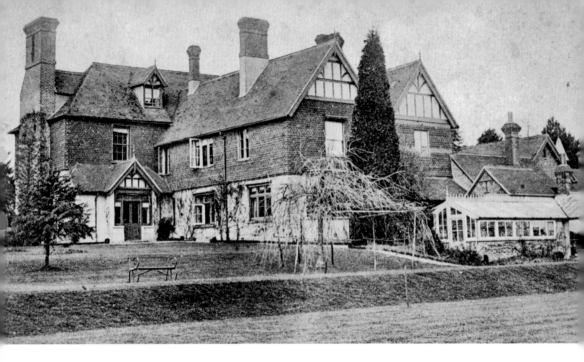

Parsonage House, Hartlip
Not to be confused with the vicarage, this is the Parsonage House, now a private house.

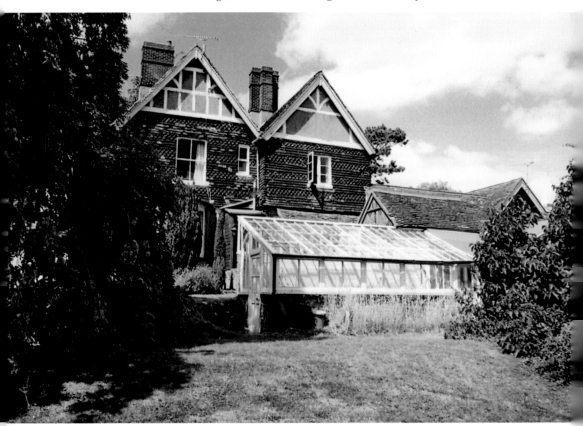

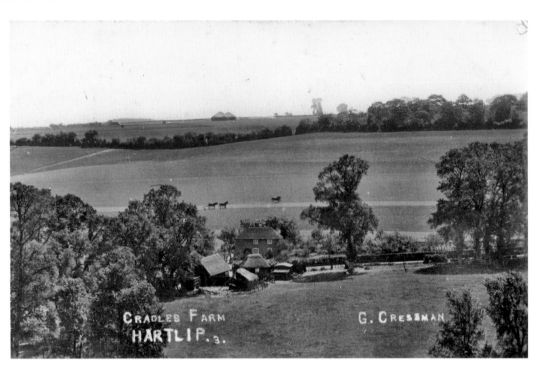

Cradles Farm, Hartlip

Looking across the land of Cradles Farm, a view that has changed very little in a hundred years or more, as can be seen in these contrasting pictures. They highlight well the agricultural nature of the landscape.

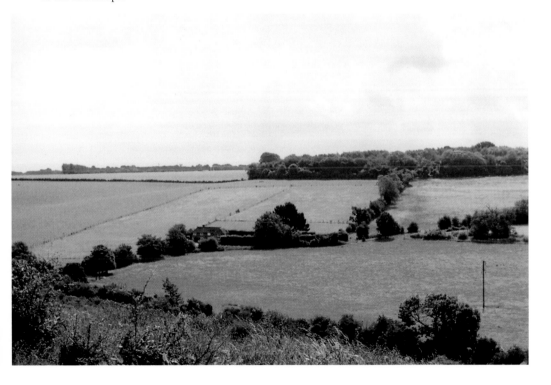

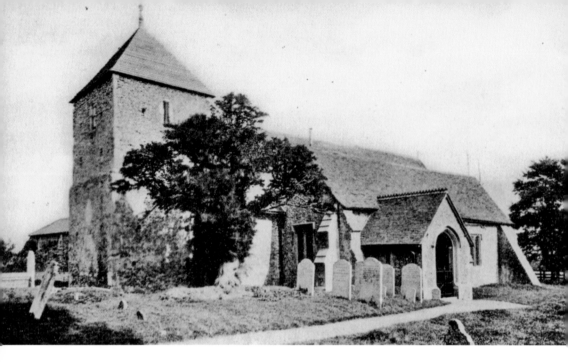

Iwade Church
Iwade's parish church is dedicated to All Saints.

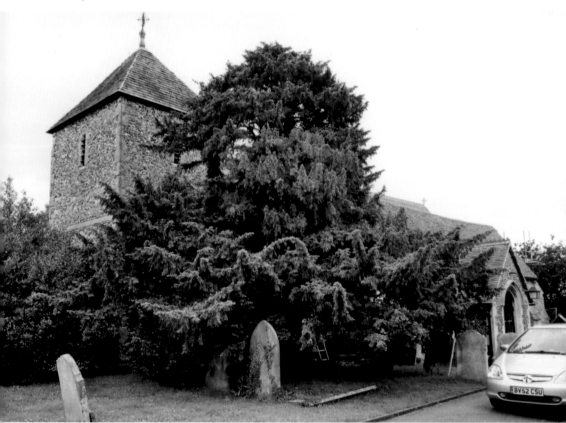

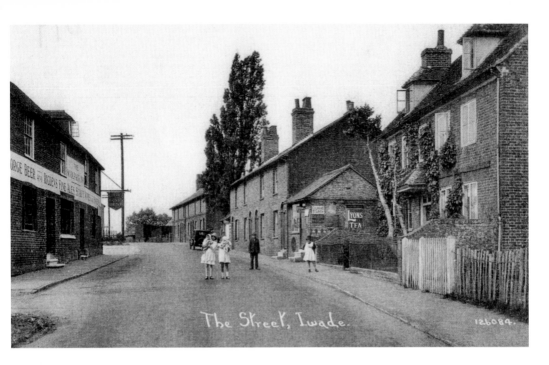

The Street, Iwade. 126084.

The Woolpack Inn, Iwade

The village is slowly losing its small village sense of character as developers build large housing estates on the surrounding fields and marshland. Whereas once the village and its inn, the Woolpack, offered a resting place for pilgrims travelling to Minster Abbey on the Isle of Sheppey before they embarked on the final leg of their journey across the marshes, Iwade is now a totally different place, being full of incomers with very modern lifestyle ideals. Even the traffic *en route* to and from Sheppey now bypasses the village, thanks to a new major road link.

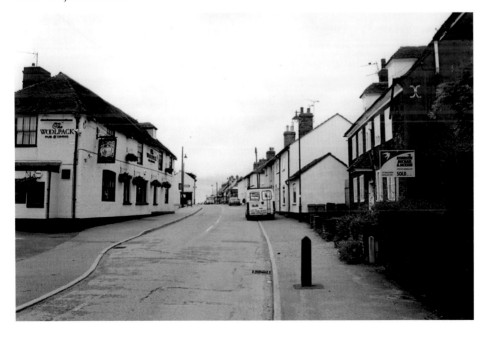

Key Street, Crossroad Settlement

A small hamlet that has long disappeared is Key Street, which once stood on the crossroads of the A2 and the A249. Today, it is commemorated by an information board standing by the roadside. Its name is said to have originated from a quay that was once here. Remember, a river once flowed down the Stockbury valley, the route of the A249, *en route* to Milton Creek. Key Street had all the ingredients of a typical village or hamlet – a pub or more properly an inn, shops, a chapel, a post office, a manor house and a garage. However, when the A249 was rebuilt in the late 1980s/early 1990s, everything was swept away, replaced by a large roundabout. Here is the crossroads as it was for centuries, photographed in 1981 and looking westwards, compared with how it is now.

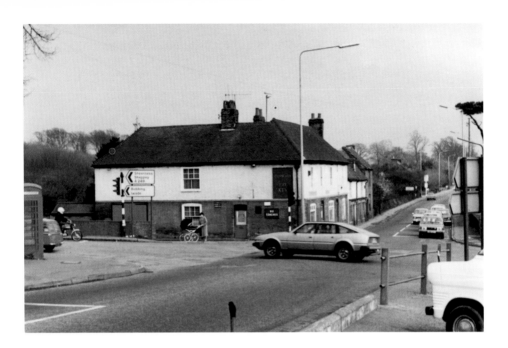

The Key Inn

Key Street's inn was the Key, a building of great, although unknown, age – photographed here in 1981. This view looks eastwards towards Sittingbourne. It no doubt served as an overnight stopping place for travellers journeying to and from Sheppey, Maidstone and all points to and from London and Dover. Key Street was located on an important crossroads. When the inn was demolished in the late 1980s/early 1990s ahead of roadworks, a local resident had the foresight to get hold of the old inn sign and incorporate it into his garden gate.

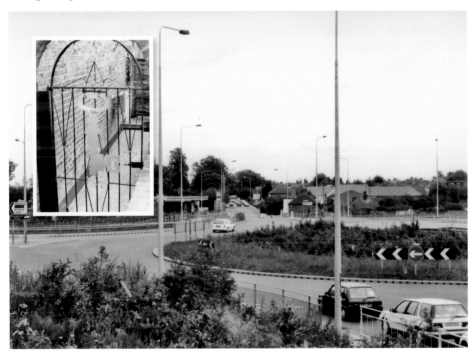

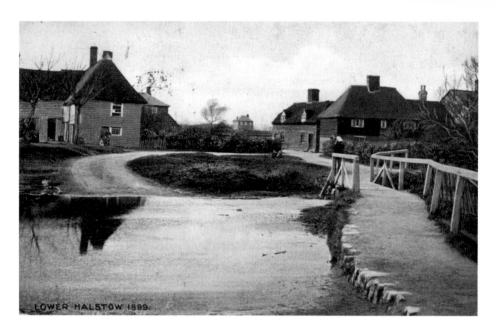

LOWER HALSTOW 1899.

Beware of the Ducks!

The village of Lower Halstow is located on the banks of the Medway Estuary and has a long and interesting history, with evidence of constant occupation since the Iron Age. Being so close to the water's edge, Lower Halstow has, until recently, been a village that has made its living from the river in one way or another. Through the making of ancient pottery, fishing and, in the nineteenth and twentieth centuries, brick-making, the river has long been the lifeblood of the village. The name of the village has developed gradually over the years and means a Holy Place (originally being Halig Stow). Ducks still swim in this stream and passing motorists are warned of their presence.

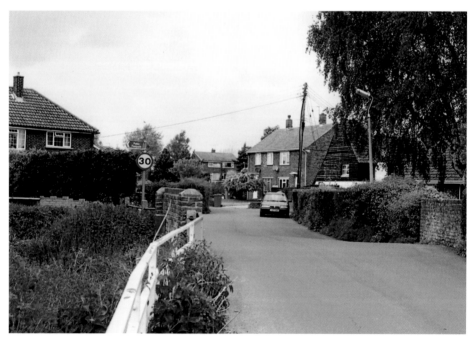

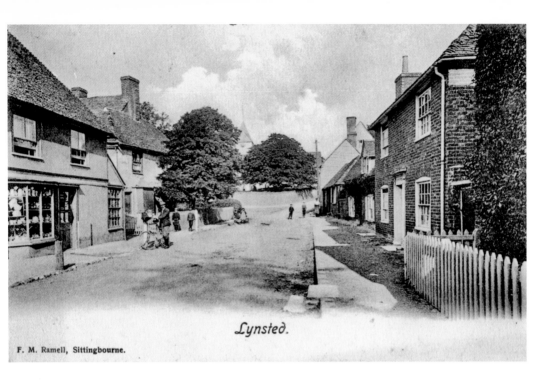

Lynsted.

F. M. Ramell, Sittingbourne.

The Village from Opposing Ends
The parish of Lynsted rises gently from south of the A2 at Teynham, over the M2 motorway to Kingsdown, and is partly within the North Downs, an area designated as an Area of Outstanding Natural Beauty. The name Lynsted is believed to derive from the Old English, meaning a place marked by a lime tree, which is now celebrated by the planting of a small-leafed lime in a pasture opposite the village pond.

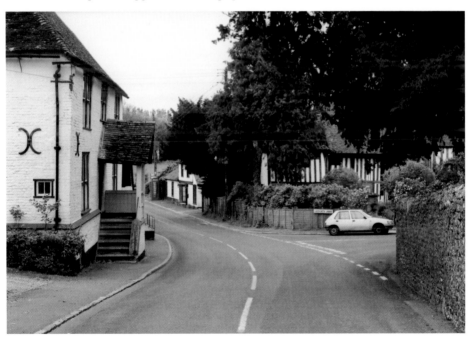

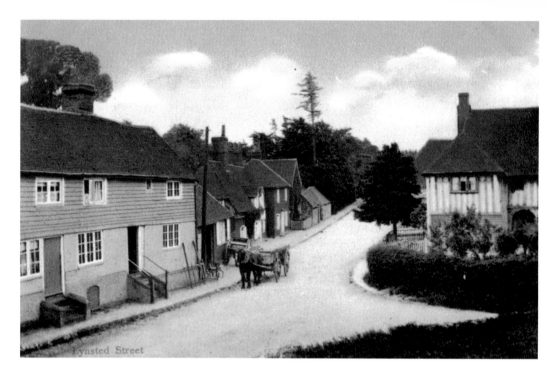

Lynsted Street

Lynsted Village from the Churchyard

Historically, the farms in the parish have enjoyed considerable prosperity, and evidence of this can be seen in the large number of fine houses dating from before 1650 that are present throughout the parish. Located on the southern edge of the North Kent fruit belt, Lynsted's orchards used to be a major feature of the landscape, but many have now been replaced by mixed agriculture. Trees make important contributions to the aesthetic character of the parish, either as field boundaries or to mark the edge of the lanes.

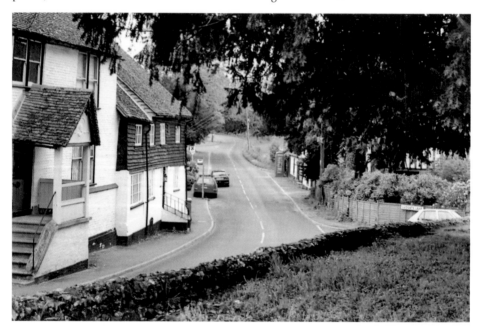

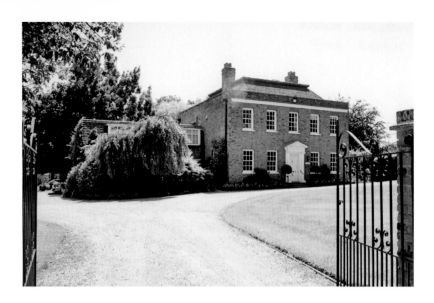

Trotts Hall House

It is hard to believe, but until the 1970s this fine old Georgian mansion stood in the centre of Sittingbourne. Trotts Hall House was originally built at the bottom of Bell Road, where today there is a small estate of private houses called Trotts Hall Gardens. For many years, the 'big house' was the home of the Boucher family who owned the departmental store, Hulburd's, but in the 1970s Mr Rex Boucher leased land at the back of his shop to Sainsbury's and was instrumental in developing the Bell Shopping Centre. As all this development started to encroach upon the land around his house, Mr Boucher had it demolished, brick by brick, and rebuilt at Milstead Manor farm.

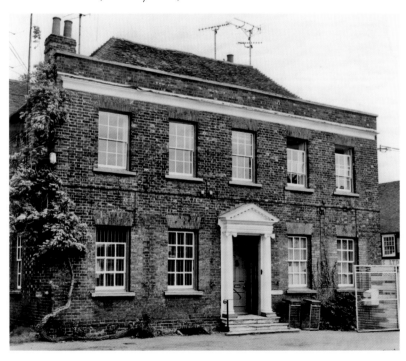

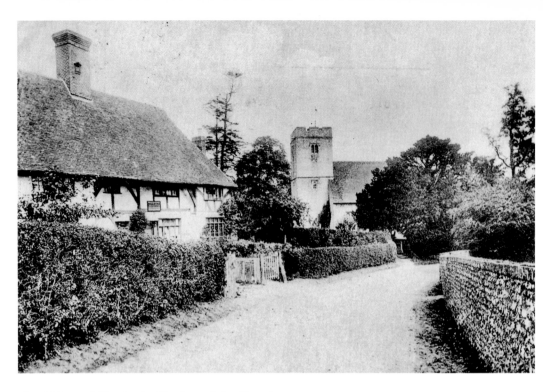

The Old Post Office in the Shadow of the Church

The name Milstead refers to its past use as a milking place, probably a small dairy farm. It is a crossroads village on the North Downs, south of Sittingbourne and just south of the M2 motorway. The church is dedicated to St Mary and the Holy Cross and is Early English/Perpendicular in style.

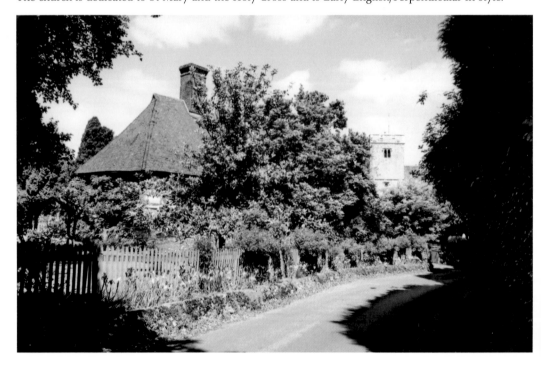

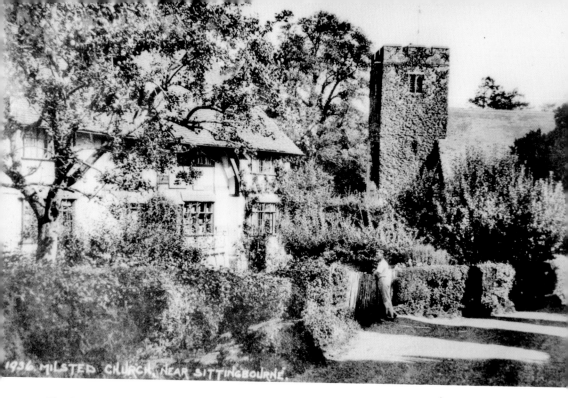

1956. MILSTED CHURCH, NEAR SITTINGBOURNE.

The Post Bus

Since 4 March 1974, the post office offered villagers from Milstead and the surrounding villages the opportunity to use the Post Bus as a means of getting into Sittingbourne to do the weekly shopping. The last public bus service stopped in May 1971. When this service was withdrawn in 2009 it left many people feeling isolated. Not everyone has a car. The villagers got together and a local taxi firm offered the use of one of its minibuses on a couple of mornings a week.

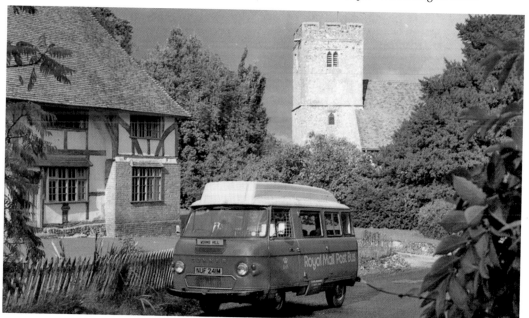

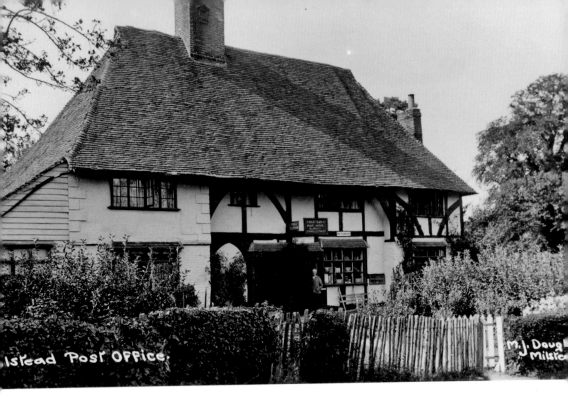

The Old Post Office
Milstead Post Office is located in a typically medieval Kentish yeoman farmer's house within a short distance of the church.

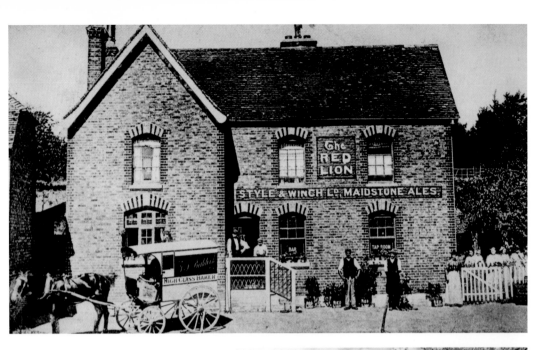

The Red Lion Pub, Milstead
The village pub is the Red Lion, located in Rawling Street. The present building has stood since 9 October 1866; its predecessor was totally destroyed one night by a fire that started in the thatched roof. This was but one devastating misfortune to face the landlord; six years earlier his wife had hanged herself during 'a temporary fit of insanity'.

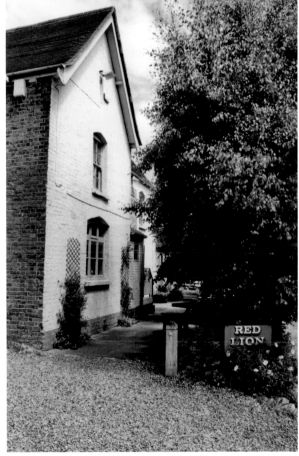

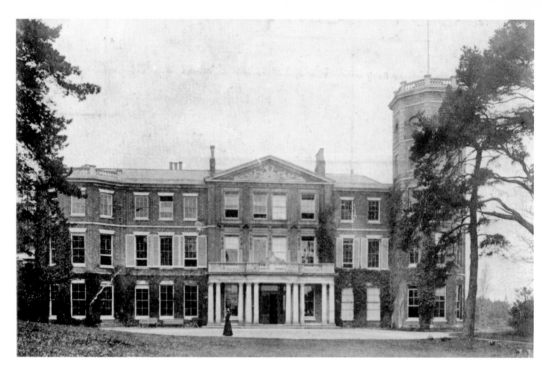

Torry Hill House

Dotted throughout Swale, there were once many 'big houses' like this, the Victorian home of Lord Kingsdown who put together the Torry Hill estate at Milstead. It was demolished in 1937, but its replacement was delayed by the war so it could not be built until 1957. The modern building has been built in an attractive style, rather reminiscent of the seventeenth century.

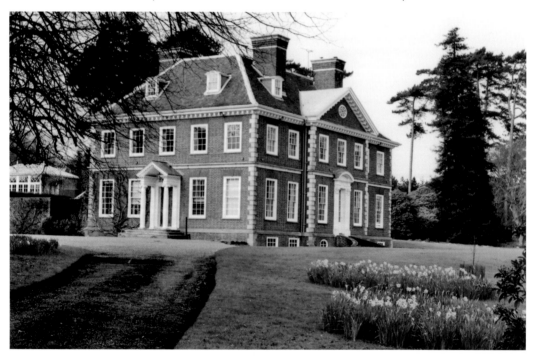

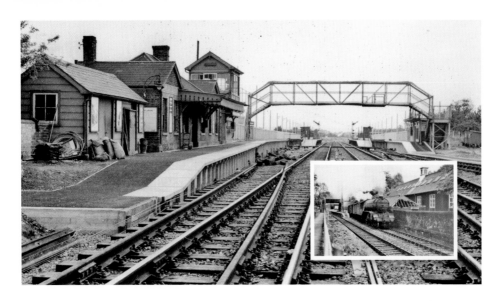

The Arrival of the Railway

The railway came to Newington in the mid-nineteenth century and the station was opened on 1 August 1862. Although the new railway served a community of some 850 people, it did not offer a passenger service until later on. As well as being of benefit to the villagers, offering them more mobility than they had ever enjoyed before, it was of greater benefit to the local farmers for transporting their produce to London and other markets more quickly. Some of the older villagers can still remember the horse-drawn carts and wagons lining up in Station Road, waiting to get their loads into the goods sheds. There was a siding near the old brickfield site, north of the A2, where Colourpacks Nursery now is. No doubt this siding was specifically for the use of the brickfield owners. The goods yard behind the westbound platform closed in 1962. (Inset) How much more evocative is the picture of a steam train than its electric counterpart?

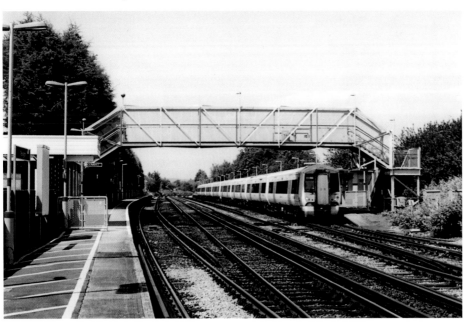

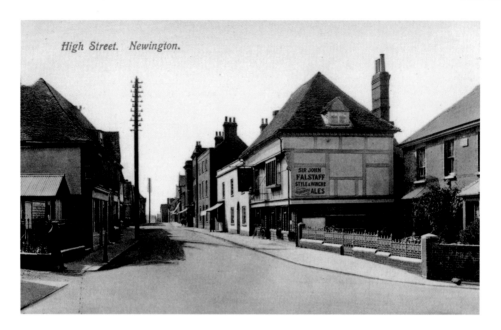

High Street. Newington.

The George Inn

The High Street, Newington, featuring the Sir John Falstaff pub, which villagers will remember as being the George. First built in 1603, the building acquired its first alehouse licence in 1763 and was then known as the Sir John Falstaff. In 1912 the innkeeper of the George that stood across the road from the Sir John Falstaff, sounded the alarm that his inn was on fire. Such was the damage to the building he was forced to cease trading. The owners of the inn at that time were the brewers, Style and Winch, who also owned the Falstaff, so they sold the site of the old George and renamed the Falstaff the George. Since being an inn, the old George has been a basket maker's workshop, a fire station, a wartime restaurant for the troops and today is an engraver's workshop.

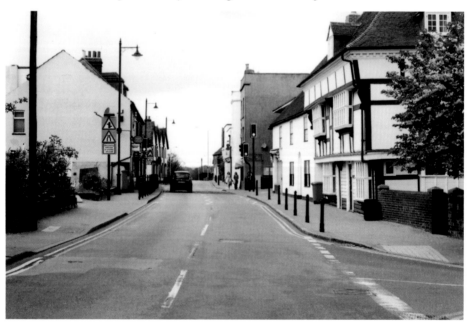

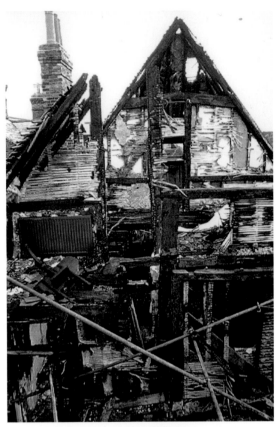

The End of an Era

On 14 February 1998, whilst the George was being converted back into a private residence, a serious fire broke out, all but destroying the building. The fire started at the back of a ground-floor chimney stack, adjacent to a void that the adjoining butcher's shop was attached to. The fire was drawn upwards through the void and began to take hold of both roofs, spreading across in both directions. The top floor and roof timbers of both buildings were severely damaged. The fire-damaged building was later bought at auction in 2003 and was restored into two generously sized dwellings.

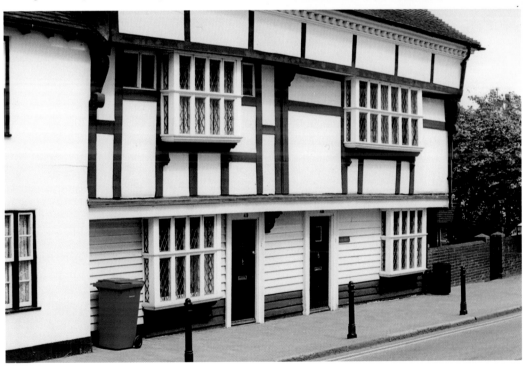

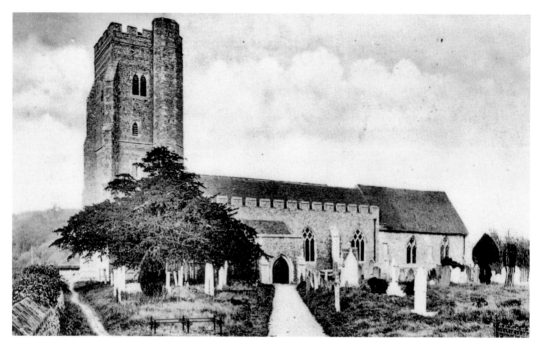

St Mary's Church, Newington
Newington's parish church is dedicated to St Mary the Virgin. The earliest parts of the church date back to the twelfth century, and although it is not mentioned in the Domesday Book, St Mary's is included in the Domesday Monochorum, a list of every church in England. Newington was a centre of some religious significance. For example, at the time of King Canute (1017–1035) the Abbot and Monastery of St Augustine, Canterbury owned eight prebends in the village, meaning that there were eight resident clergymen here who were expected to officiate over the villagers.

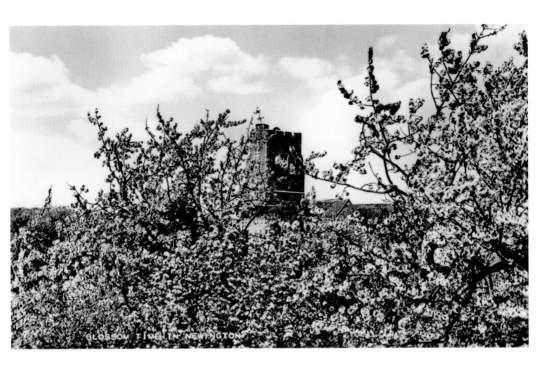

The Church Amidst the Orchards

St Mary's church is often described as 'the church amidst the orchards', a title acquired as it is surrounded by orchards. The best time of the year to see this spectacle is spring time when the fruit trees burst into blossom. It really is a spectacular sight.

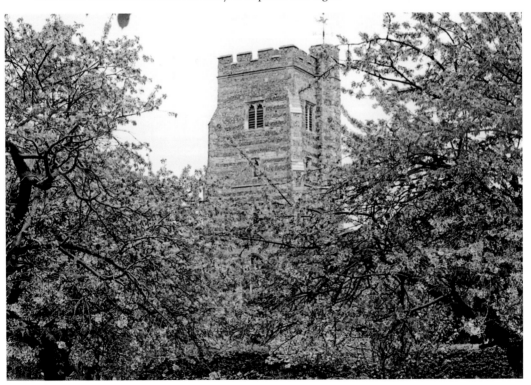

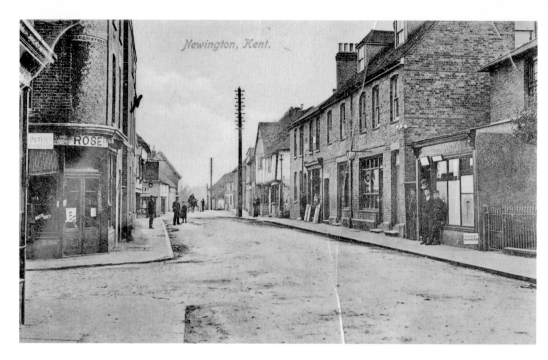

The Corner of Station Road and the High Street

The railway station was opened in August 1862 and although it could not be used for passengers, a road had to be built before it could be opened connecting the station to the High Street – named appropriately, Station Road. This is its junction with the High Street in 1910, opposite which was the village's first post office. The old post office on the corner of Station Road is currently an Oriental food restaurant/takeaway.

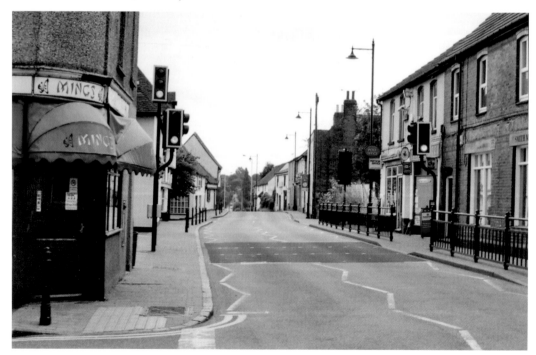

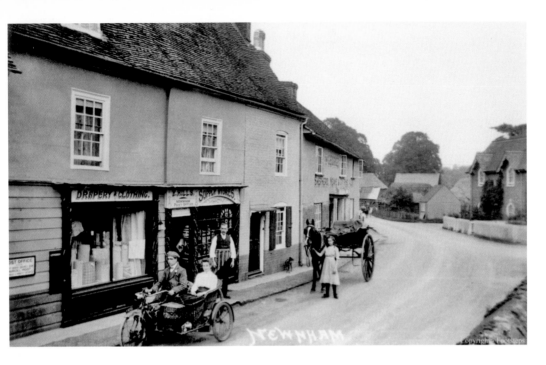

Village Shopping in Newnham

The changing face of Newnham's shopping centre. The village once had a couple of shops standing next door to the George inn, as you can see in this old picture of unknown date. Today they are private houses and there are no shops in this hamlet.

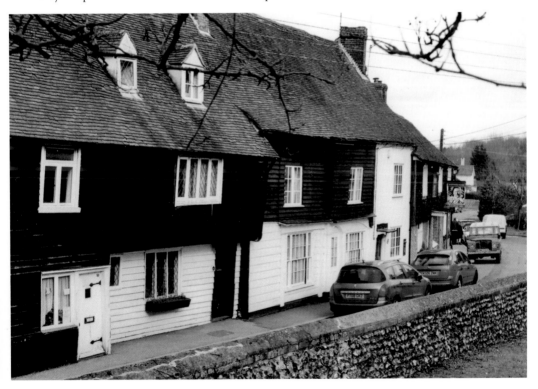

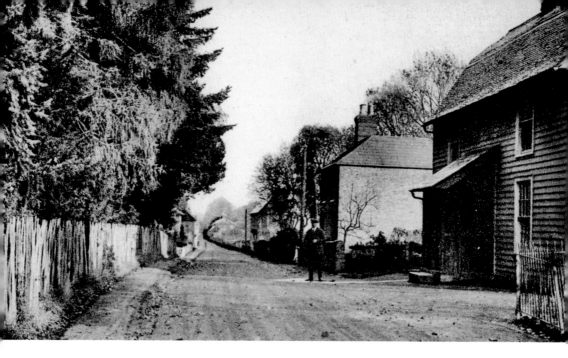

The End for the Pub

As well as the George, Newnham once had another pub, the Royal Oak, but after it closed at an unknown date it became a private house.

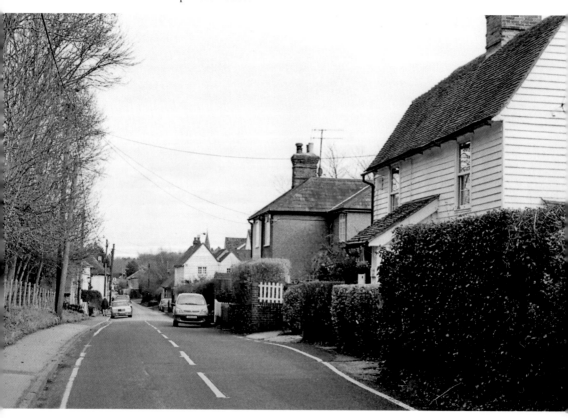

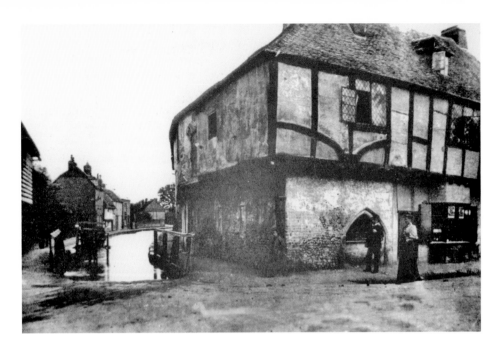

A Medieval Travelodge

Ospringe is located on the A2 road just outside Faversham and, in earlier times, was a Roman town known as Durolevum. It was a required stopping point for the pilgrims travelling either to or from the tomb of Thomas Becket in Canterbury, so that they could divert into Faversham to visit its abbey, and the tomb of King Stephen and his wife, Queen Matilda. Here we see the Maison Dieu, a building built in the Middle Ages to accommodate travellers like the pilgrims. Like certain parts of Sittingbourne, Ospringe also had a stream crossing the main road *en route* to Faversham Creek. The top picture, taken in *c.* 1890, shows the stream flowing down Water Lane, but today this is a rare sight.

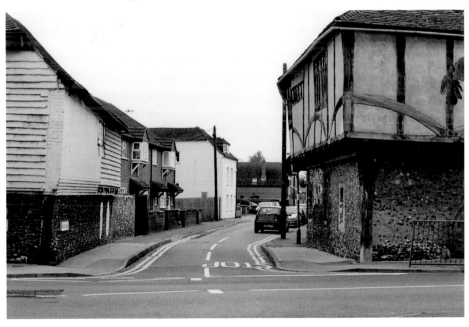

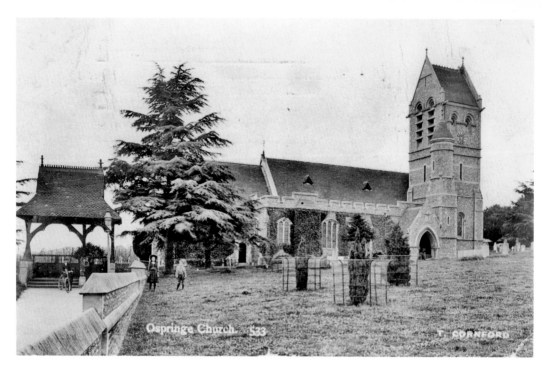

St Peter and St Paul's Church, Ospringe

Ospringe's parish church is dedicated to St Peter and St Paul. It shares an architectural feature with Tunstall church, something I've not encountered with any other churches in this part of Kent. I refer to the tower roof, which is French in style and covered by a tiled pitched roof like a house.

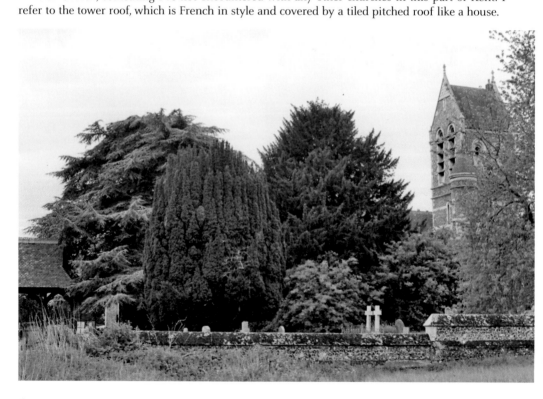

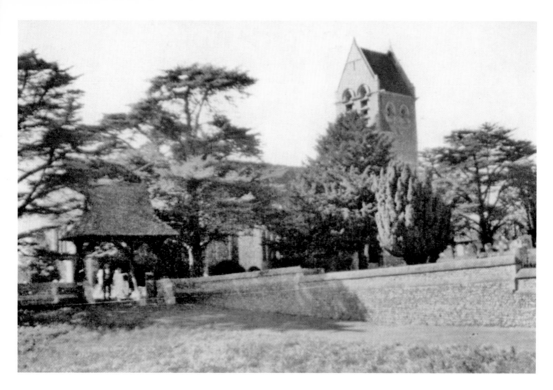

The Church from a Different Angle
Another view of St Peter and St Paul's church, which once enjoyed a very open aspect. Ever-growing foliage now hides this little gem.

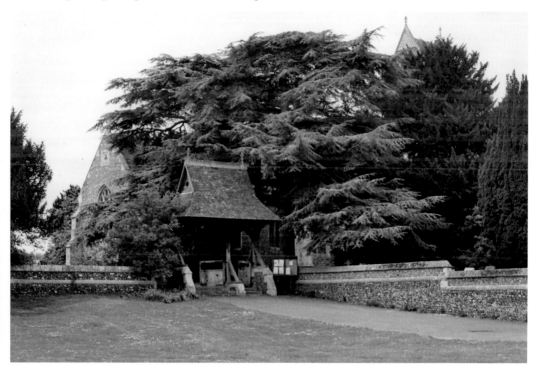

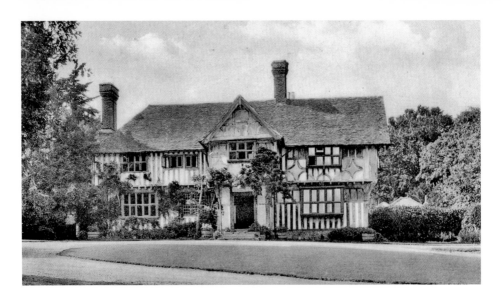

Queendown Warren House

The name Queendown Warren first appears simply as Queen Down but, as it had a warren – a place where rabbits were bred – it soon became Queen Down Warren and the first two words conjoined. The queen referred to is not Elizabeth I, as was once commonly thought, but Eleanor, the widow of King Henry III. In 1273, she granted to the hospital of St Katherine in London, 'all her lands in Renham and Hertlepe in Kent and Roed in Hertfordshire'. It was this that gave the name to Queen Court in Rainham and Queen Down in Hartlip. The first mention of the 'Warrren' suffix is recorded in 1621 when Edward Osborne refers to Warren House, now called the Cradles (*see also* p41). In 1642, the rent of this house and farm included '52 couples of conies, sweet and clean, and of the best of the game yearly'. It is a typical fifteenth–seventeenth century building, timber framed and exposed with plaster and red brick infill, with plain tiled roof, and a lobby entry range with cross-wing. It is built two-storeys-high on a plinth, with hipped roofs and stack to centre-right.

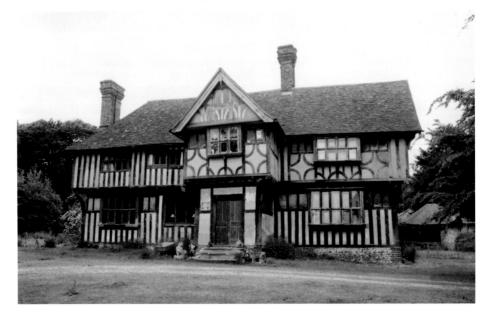

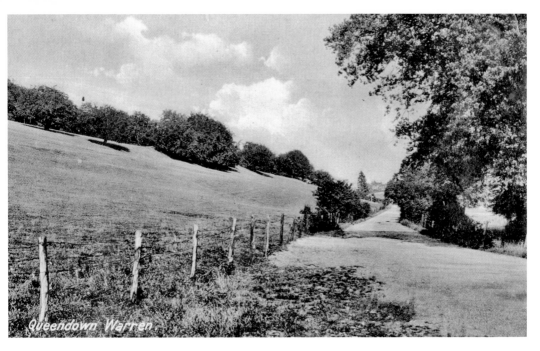

The Highways and Byways of Queendown Warren

Although it is no longer a village as such, there are some pretty little byways to explore once you are off the main highway. Such is the diversity of its wildlife, Queendown Warren is now a wildlife reserve managed by the Kent Wildlife Trust and covering an area of some eighty hectares. At its core is the original medieval rabbit warren.

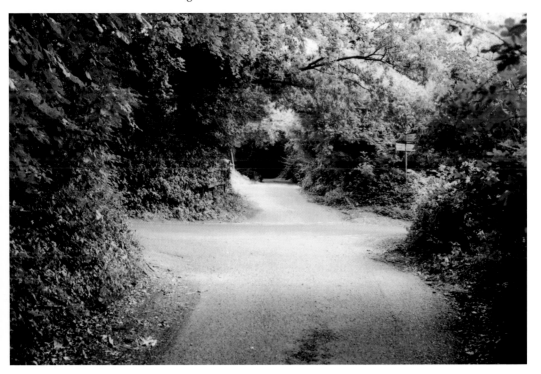

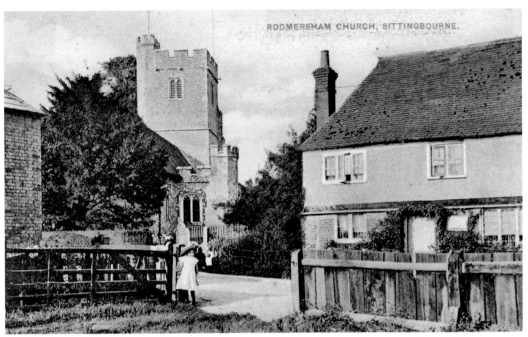

A Divided Village

Rodmersham is a village of two halves – most of its facilities, such as housing, the shop, the pub and the school, are grouped around the village green, whilst the church, dedicated to St Nicholas, stands a mile or two away to the north amidst farmland. The earliest known mention of Rodmersham was made between 1154 and 1187, when King Henry II gave the church to the Knights Hospitallers of St John of Jerusalem, a gift later confirmed by King John. It is known that the chapel, probably just a small wooden structure, was dedicated in 1199. As settlement names ending with 'ham' are of Anglo-Saxon origin, there must have been a community living here prior to the Norman Conquest, originally headed by a chieftain named Hrothmaer *c.* 700–800 AD.

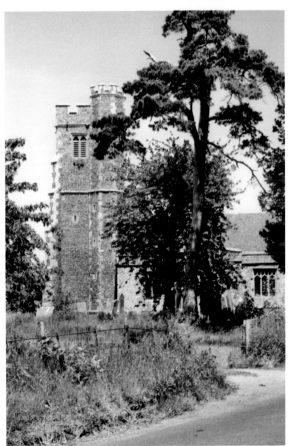

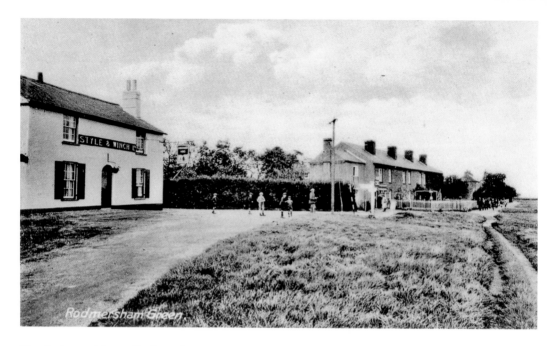

The Fruiterers' Arms, Rodmersham

The village pub, the Fruiterers' Arms was built *c.* 1835, on a piece of former farmland, by William Kemp, a local carpenter. It is thought that Kemp might have incorporated part of an earlier farm building into his new building. Three years later, he set up his son, William Jr, as the pub's first landlord. With huge debts hanging over him, William Jr sold the pub in 1851 to Medway Brewers, a firm that later became Holmes & Style, and later Style & Winch. From 1851 licensees became tenants, the first of which was William Fever who, in 1854, was summoned to appear before the magistrates for serving customers after hours.

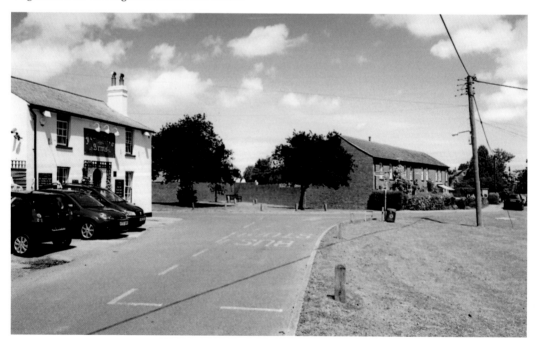

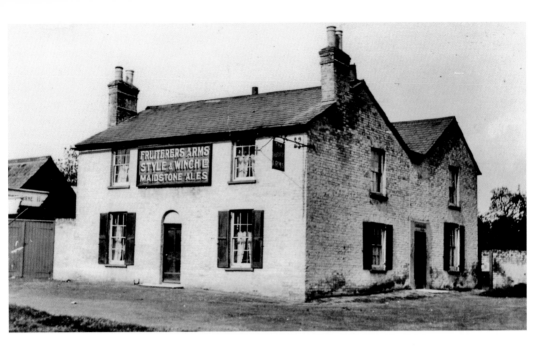

At the Heart of the Village

The Fruiterers' Arms has been used by undertakers as a mortuary, in an outhouse of course, in the nineteenth and early twentieth century. Inquests have been held here and during the Second World War the Home Guard used the pub as their headquarters. The pub is said to be haunted by the ghost of Billy Whiffen who lived in its loft and helped out in the pub and around the village. On his death he was given a pauper's funeral. Over the years, the pub has played host to a number of village events and continues to be a popular watering hole for villagers and those who live beyond it as its restaurant facilities have been expanded.

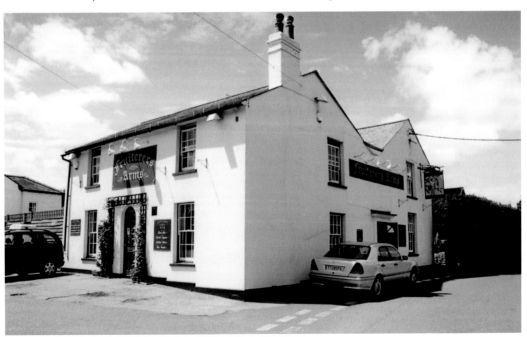

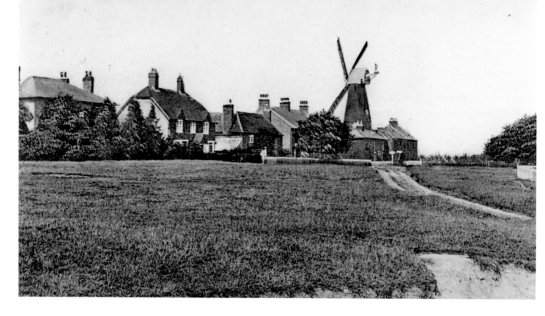

Rodmersham Green.

The Story of the Windmill

The village once had a windmill overlooking its green. By the late 1960s however, it had become run-down and derelict, so it was decided to demolish it. Until the end of the Second World War, the adjoining five cottages had been occupied by farm workers, but were now empty. Amidst considerable uproar by the villagers, the mill was demolished. A Mill Preservation Society was hastily formed and some villagers tried to stop the demolition by lying down in front of the bulldozers, but all to no avail. In its place Mill House was built in 1970.

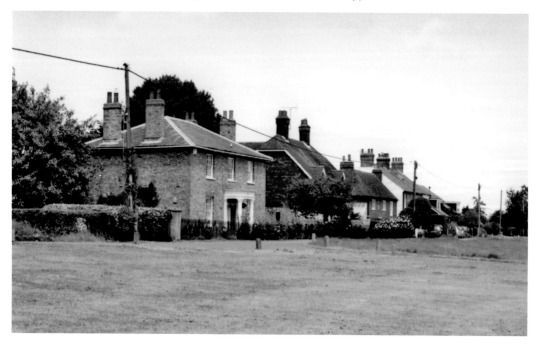

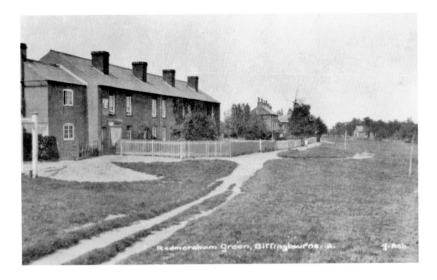

Rodmersham's Village Green

Village greens have long been a place where villagers could graze their animals and hold public events. They have been taken for granted and today few people are concerned about exactly how such a space has survived over the centuries. To preserve the tradition, the Commons Registration Act, 1965, was introduced to ensure that, by registration, all commons and village greens are preserved. Rodmersham Green was declared to be a true village green by a Commons Commission Inquiry in 1976, but in 1982 a further inquiry heard evidence and claims over the actual ownership of the green. It appeared that part of the green was held by virtue of the Lordship of the Manor of Milton and part by the Lordship of the Manor of Rodmersham. As no claim for registration had been made by the Manor of Milton, the claim for registration by the Manor of Rodmersham was upheld. It resulted in a decision that the main part of the green lies within the Manor of Rodmersham whilst the remainder, two small areas in the vicinity of the larger pond, the school and the village hall became registered with the parish council as owners.

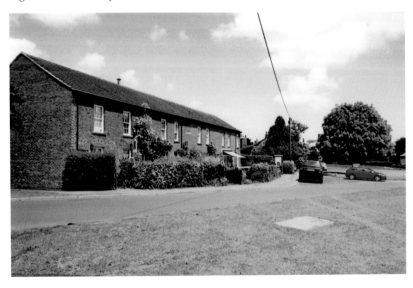

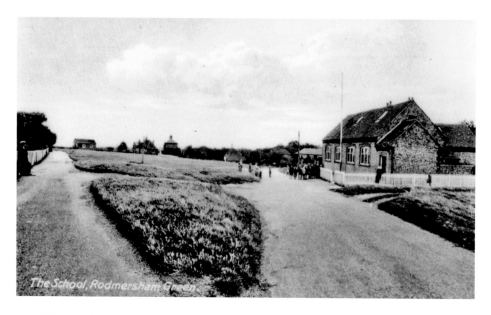

The School, Rodmersham Green.

The Village School

Rodmersham school was founded in 1869 when the village population was 300 and there was no school within easy reach. Thanks to the vicar, Revd T. O. Drawbridge, and churchwarden, Frederick Lake, plans were drawn up to build a school in the village. The land upon which it would be built was donated by Baroness Wenman, Lady of the Manor of Milton, and grants to finance the building costs were made to the National Society for Promoting the Education of the Poor in the Principles of the Established Church, and the Diocese of Tunbridge Wells. The school remained a Church of England school until the expense and maintenance became too great for the parish, and in 1940 it was transferred to the Local Education Authority. The links between the school and the church did, however, continue. The original school consisted of just one classroom, which can still be seen fronting on to the road, but in 1903, following a School Inspector's report, a new infants' classroom was added as well as a second cloakroom/scullery.

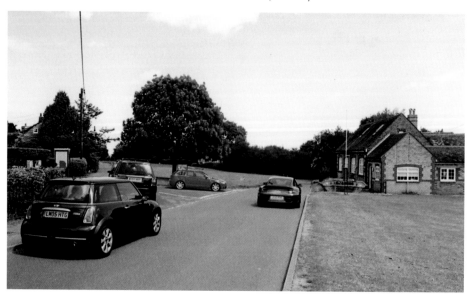

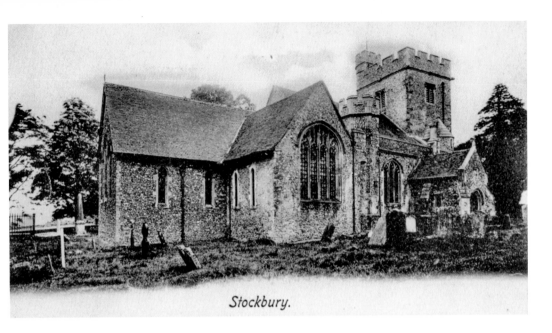

Stockbury.

Stockbury Church

This view, overlooking the Stockbury Valley – through which runs the A249 Sheerness–Maidstone road – is of Stockbury, which is 4 miles south-west of Sittingbourne. The parish is part of the area designated the Kent Downs Area of Outstanding Natural Beauty; it is a Special Landscape Area and is classified as a Nature Conservation Area. The original settlement, Stochingeberge was centred on a castle, of which no tangible evidence remains. It stood adjacent to the parish church, which is dedicated to St Mary Magdalene, a late twelfth-century building.

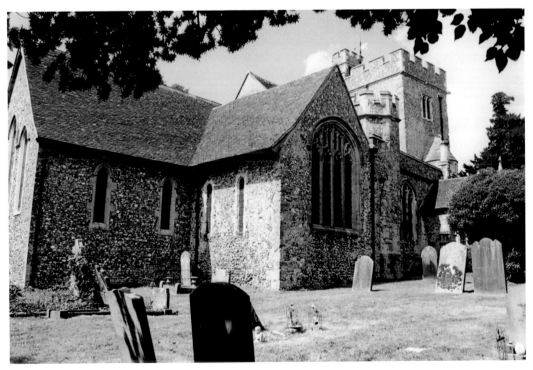

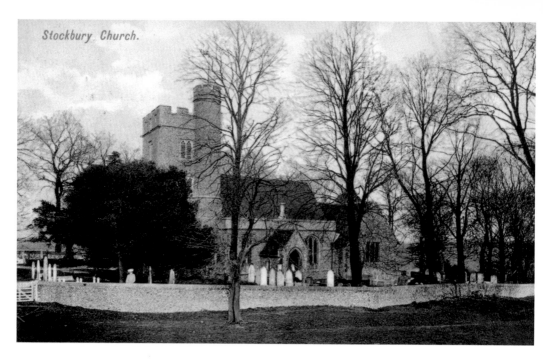

Stockbury Church.

An Expansive View

St Mary Magdalene church not only overlooks Stockbury village but also much of the Stockbury valley, through which, in earlier times, flowed a mighty river that made its way to Milton Regis and the creek beyond. It was one of several to flow off the North Downs, heading for the Swale or one of its many inlets. Stockbury's church can be seen for miles around, as the second picture attests.

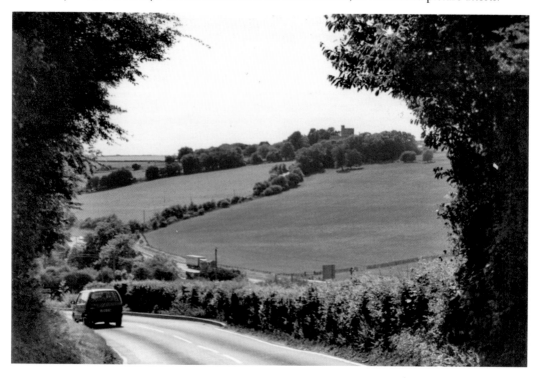

76

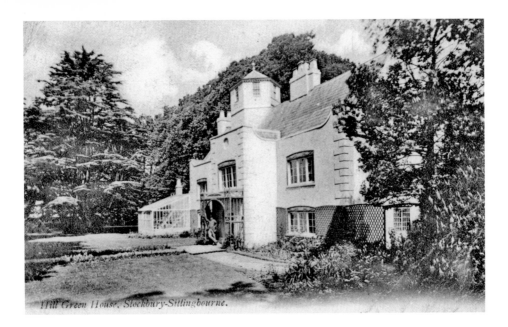

Hill Green House, Stockbury-Sittingbourne.

Hill Green House, Stockbury

One of Stockbury's oldest buildings, of which I have managed to obtain a picture, is Hill Green House, but as can be seen in the later picture it now no longer bears any resemblance to the former, taken early in the twentieth century. The original manor, of which this was a part, dates back to the time of Edward I (1272–1307) and probably even earlier. The manor had several notable owners during its life, but in 1921 burned to the ground. There was no nearby water supply to douse the flames and the local fire brigade took forty-five minutes to get there. The derelict site was purchased by Mr Frank Rule in 1939 but because of wartime restrictions, he could not start rebuilding until 1946. Using the old stables and coach house as a basis, this was connected to the old Tudor barn by a wide corridor in the 1970s.

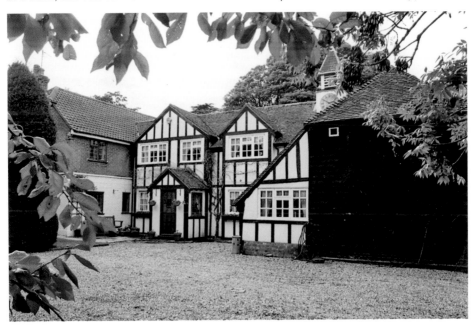

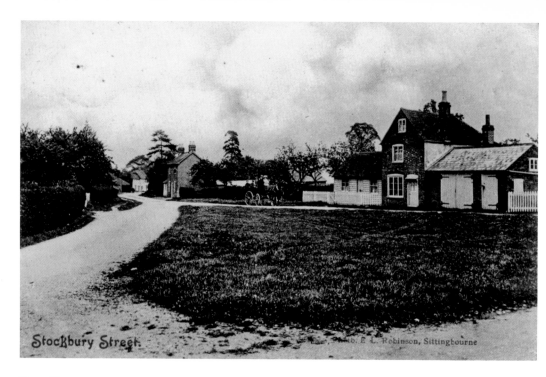

Stockbury Street. Photo. E. L. Robinson, Sittingbourne

The Village Green

What could be more typically English than the village green overlooked by the village pub, and here in Stockbury we have exactly that. A tree has now been planted on the green, behind which is one of the original cottages, now greatly enlarged by incorporating the outhouses on either side.

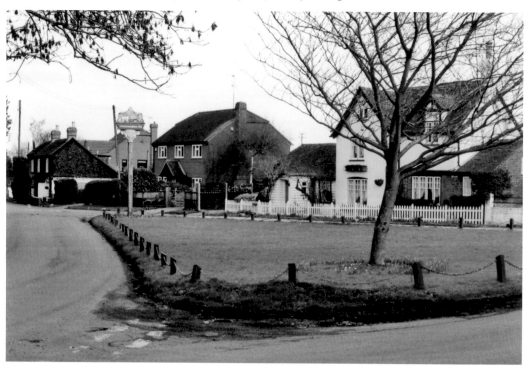

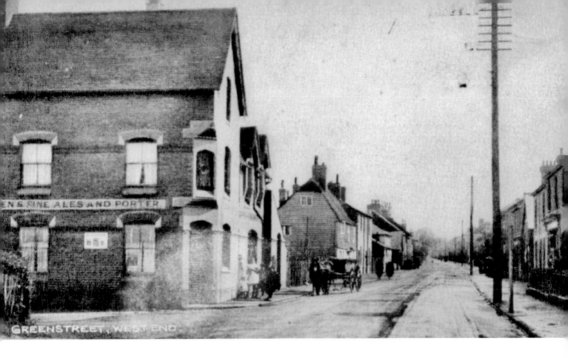

The Former Fox Pub

As you enter Teynham from the western end, one of the first buildings travellers would have encountered is a small pub, the Fox, which in recent years has been transformed into a block of flats although it still retains its original architectural character. Once a pub, always a pub!

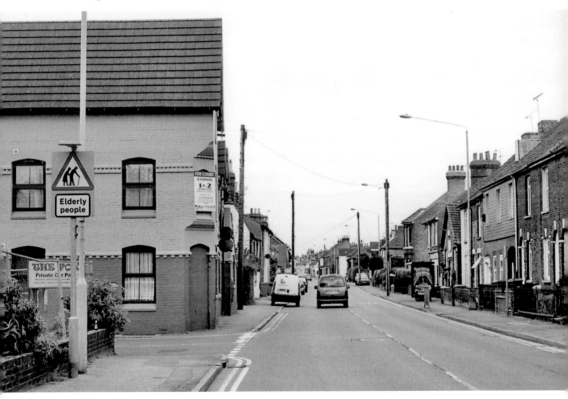

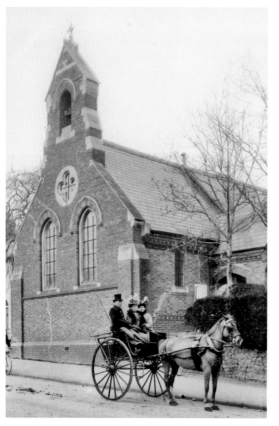

St Andrew's Church, Green Street

This photograph is bound to puzzle anyone who does not have a detailed knowledge of Teynham so first I'll tell you where it once stood. It was at the far eastern end of the village, on the brow of the hill, almost opposite the Dover Castle inn, on the northern side of London Road. Today, no traces remain of this church – except one small clue. If you look at the retaining wall in front of the horse, it is still there to this day, almost intact. What do we know of this fine old brick-built church? It was built sometime after 1887 and was damaged when a bomb landed nearby in 1940. The damage was repaired but the church was later demolished.

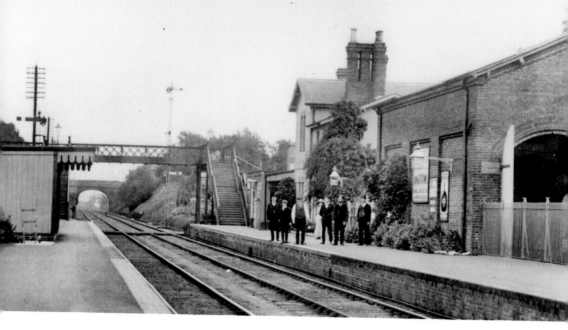

Teynham Railway Station

Like several other towns and villages located along the A2 road, Teynham's economy was based on agriculture and industry. The arrival of the railway here in 1858 marked a turning point for the village. Farmers and industrialists could now get their goods to market much quicker than previously when they had to rely on road and water-borne transport. On Friday 26 January 1858 the East Kent Railway opened its line from Chatham to Faversham. At first there were just six trains a day in each direction, calling at Rainham, Sittingbourne and Teynham. The new station had a large goods yard and a splendid house for the stationmaster, but that has long been demolished.

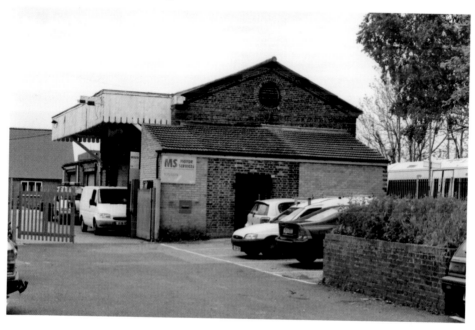

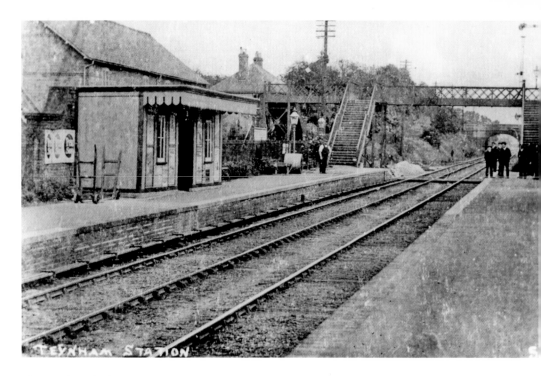

The Station Platform

Teynham railway station was quite modest in size with its two platforms and a bridge for passengers to cross the line. To the right of the picture can be seen the goods shed where produce was loaded on to the goods trains. As humble as the waiting room was, even that has been reduced today to little more than a bus shelter.

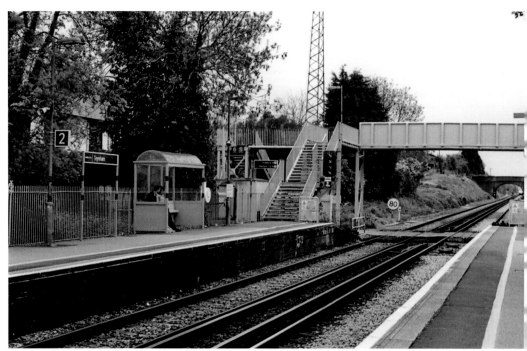

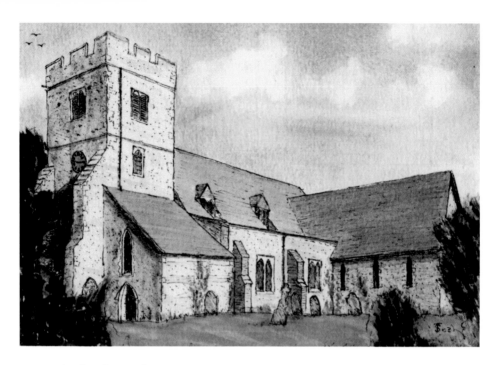

St Mary's Church, Teynham

The parish church is dedicated to St Mary and has long been known as a church of early foundation, being recorded as one of Kent's pre-Conquest minster churches. Although the present building is predominantly a thirteenth- to fifteenth-century structure, recent archaeological investigations have brought to light the existence of the fabric of a much earlier building. The church is a part of a much larger complex. Immediately to the south lie the buried remains of the gatehouse and ancillary buildings of the thirteenth century Archbishop's Palace which is located further north-west, adjacent to Teynham Street.

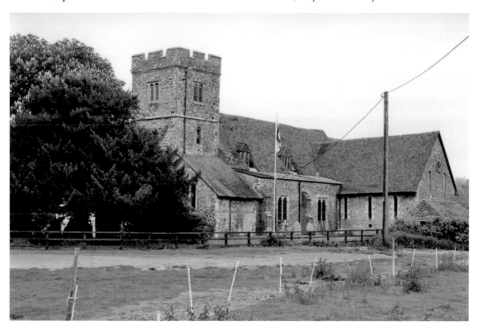

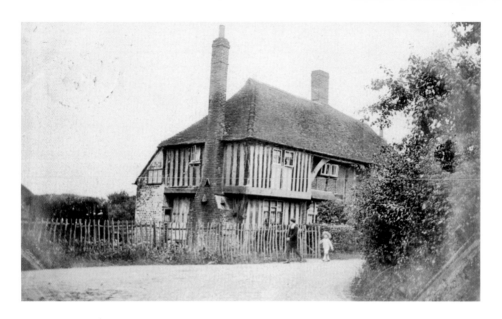

Banks Farm Cottage, Teynham

This fine example of a Kentish Wealden hall house stands in Teynham Street, once the epicentre of the village before it migrated northwards to its present location on the A2 road. Wealden hall Houses were timber framed farmhouses built by wealthy Yeoman farmers from the late-1300s to the mid-1500s. Originating in the South East, in the Weald of Kent and Sussex, they spread to other Southern counties around England. They remain most prevalent in the South East however, particularly in areas surrounding Maidstone. The buildings can be identified by their distinct front jettied first floor end bays. Looking remarkably unchanged from the earlier views taken in 1908 and 1909, this is Banks Farm Cottage, a Grade II listed building.

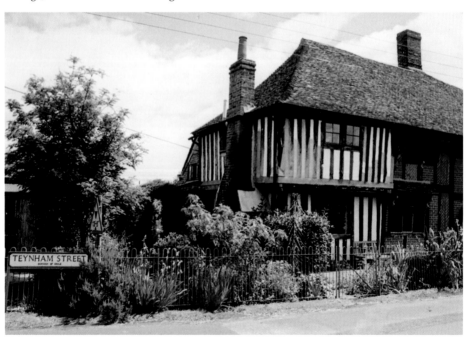

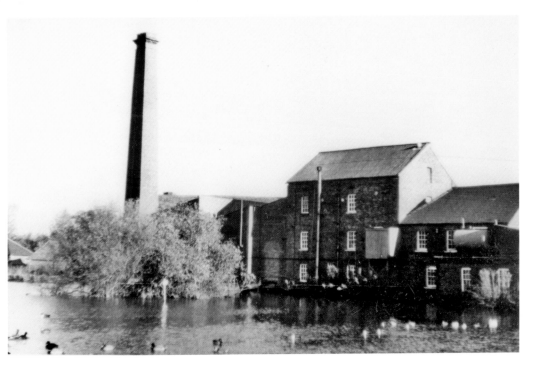

Tonge Mill

Between the wars in the 1920s and 1930s, Tonge mill was a popular picnic spot with local residents. The tiny hamlet was centred on a mill and although the chimney, built with locally made bricks, was constructed in 1837, the main millhouse, clad in its traditional white weather-board, dates back to 1759. At one time you could hire a small boat to row around the millpond. Overlooking the mill pond was once a castle but today, with the castle having long been demolished, a bungalow sits atop the remains of the castle's motte, or mound.

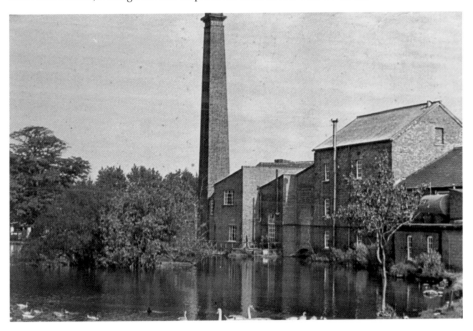

The Main Road Through Tunstall

Tunstall is a small village, located just to the south of Sittingbourne, and is set amidst orchards and other agricultural land. Even though it is still a separate and individual village, the band of land separating it from Sittingbourne is slowly shrinking as new housing slowly encroaches. Tunstall is one of those unique villages that has neither a pub nor a village shop, and never has. Why? This is something I have yet to discover. This is the main road through the village as it passes the entrance to the church on the left of the picture. Today, the trees and other foliage have been allowed to grow, and to drive through this part of the village is like driving through a tunnel. It is particularly pretty in the winter when the trees are covered in snow.

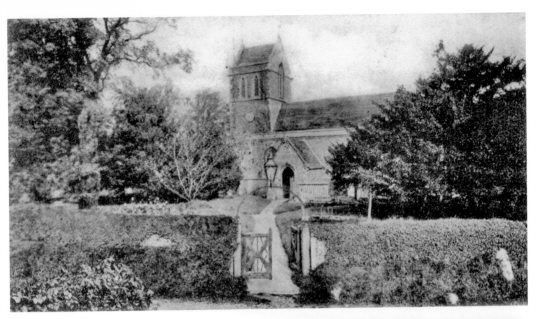

St John the Baptist Church, Tunstall

Tunstall parish church is dedicated to St John the Baptist and its first rector, Lambert de Monetto, is recorded as having died in 1287. He must have been a busy man because he was also the Rector of Southchurch in Essex and Canon of South Malling; today's incumbent, Revd Keith McNicol has only Rodmersham to oversee as well. Interestingly, one of Tunstall's rectors, Simon de Mepham, became Archbishop of Canterbury later in his life from 1328-1333.

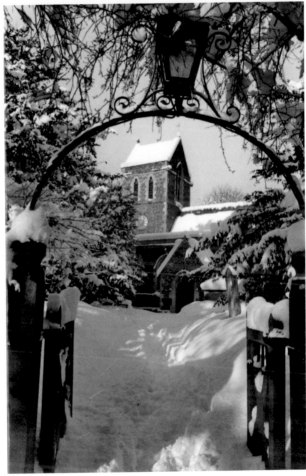

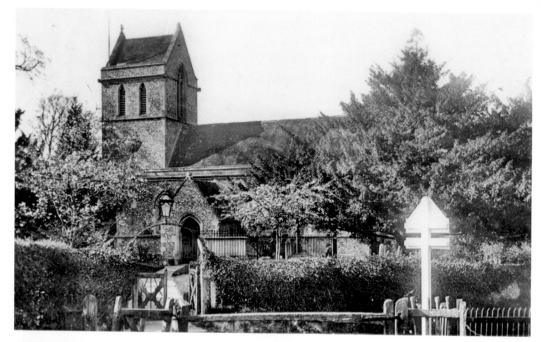

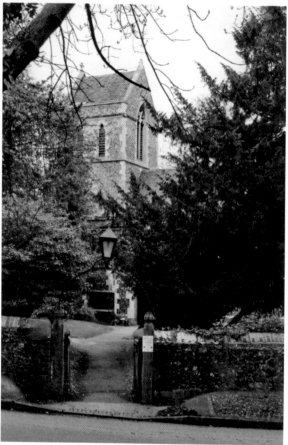

A Quirky Tower

St John the Baptist church shares an architectural feature with at least one other local church, St Peter and St Paul, Ospringe. I refer to the pitched roof over its tower but who acquired this feature first it is not known with any certainty. However, a sketch of the church drawn in 1712 reveals that since then the upper part of the tower has been rebuilt, with the addition of the pitched roof, and the original castellated wall over the south aisle has been replaced by a plain parapet. Also, the porch has been rebuilt and given a pitched roof, and the windows in the south aisle renewed. And we all tend to think that buildings like churches remain unchanged over the years.

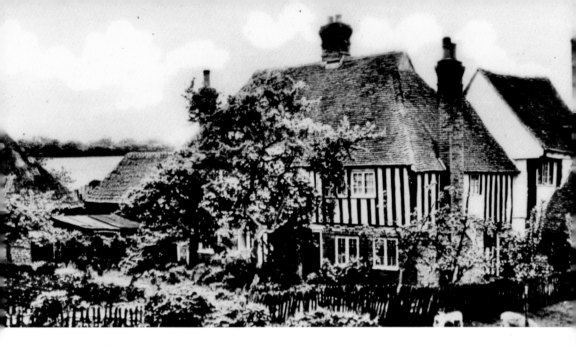

Hearts Delight

Another Kentish Wealden hall House, Hearts Delight, stands on the boundary between Tunstall and the neighbouring parish of Borden. Its cottage garden transports you back in time to another age when life seemed to be idyllic.

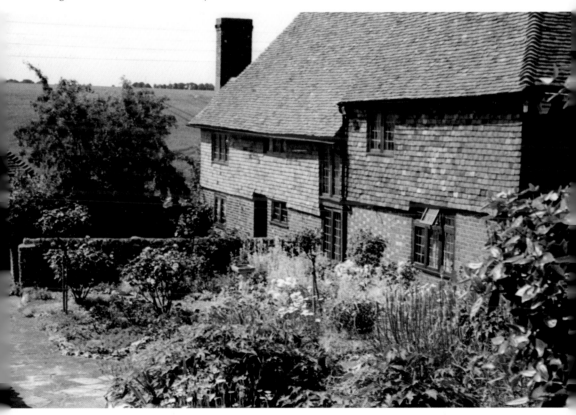

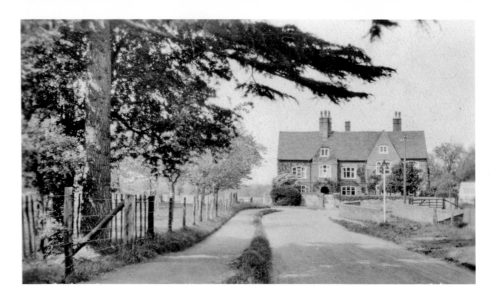

Hales House, Tunstall

Hales House with the historic Coffin Pond and the original village sign in front of it. The house was built at the beginning of the seventeenth century for John Hales, the son of Sir Edward Hales of Tenterden who was created a baronet in 1611. John predeceased his father in 1639 so his son, Edward became the second baronet. Such was his support of the monarchy, after the Restoration he had to live abroad in consequence of the debts he had incurred and subsequently died in France. The third baronet was also named Edward and he continued the family's strong allegiance to the monarch. It is said that whilst trying to flee from England, King James II took refuge at Hales House one night as he was a firm friend of Sir Edward. Myth or truth? Who knows: it is one of those delightful local stories that we can never be sure of. The house you see today is a mere shadow of its former self; that fell into a ruinous condition in the early-eighteenth century and has since undergone at least two major restorations. The porch and the centre portion are all that remain of the original building. To the left of the house, where once there was orchards and open countryside, there are now roads and houses.

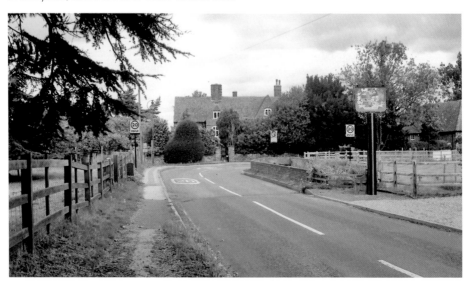

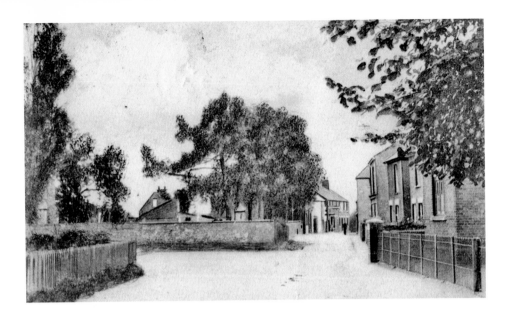

Upchurch Village Centre

The westernmost village of the Swale collection is Upchurch which stands on the banks of the River Medway as it enters its estuary. The village is ancient in its origins; it is said the Romans had a pottery industry here, now referred to as Upchurch ware. More recently, the industry was re-established here in 1909, called the Upchurch Pottery. Although it is now closed, it became well known and could be found retailing through such outlets as Liberty & Co. Upchurch lay on a pre-Roman trans-Kent trackway and the many linking roads are the result of Roman occupation. A Roman cemetery has been discovered here, if further proof was needed. Although today the land is low-lying and marshy, it was once higher than it is today. The village has a connection with Sir Francis Drake whose father, Edmund, became its vicar in 1560 after having been prayer-reader to the Medway fleet. As seems to be the case with most villages, Upchurch's main road connecting it to the A2 road, is called The Street. In 1907 there were considerably less cars than today.

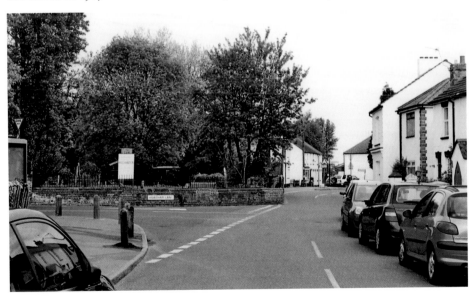

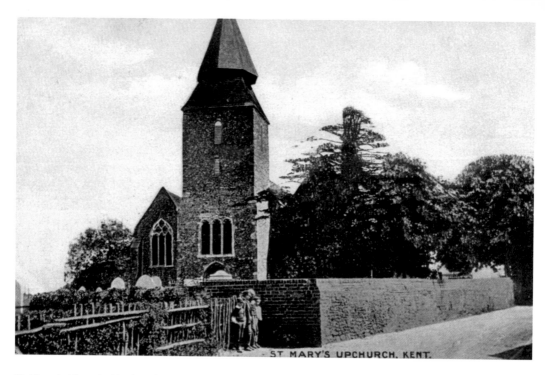

ST MARY'S UPCHURCH. KENT.

St Mary's Church, Upchurch

Upchurch's fourteenth-century parish church is dedicated to St Mary the Virgin and its most distinctive feature is the candle-snuffer design of its steeple where an octagonal pyramid appears to have been stacked on top of a square one, resembling a couple of inverted ice-cream cones.

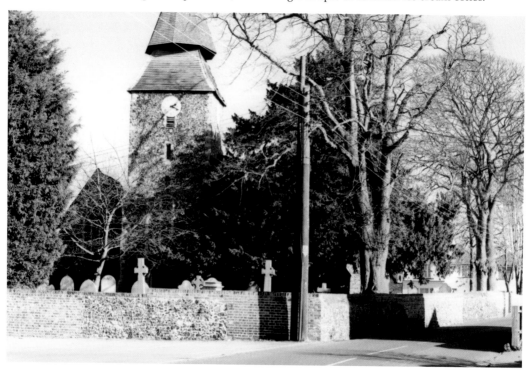

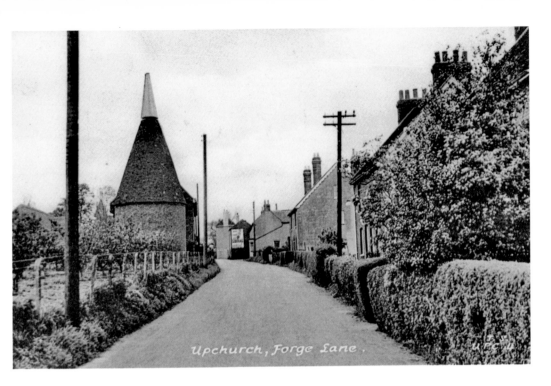

Upchurch Village School

A sign of yesteryear, showing the village's agricultural past, Wakeley's oast house in Forge Lane in the early-1900s where hops were dried before being sent off to the breweries. Today the village school occupies the site of the oast house and its adjoining orchard.

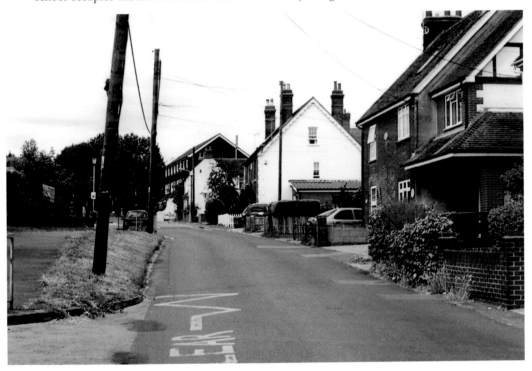

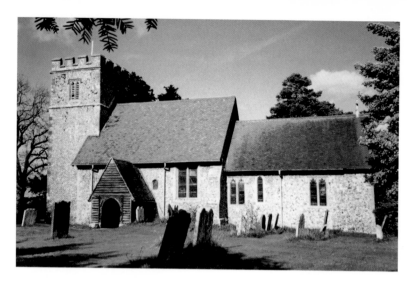

St Giles Church, Wormshill

One of our strangest-sounding village names must be Wormshill, but it has nothing to do with worms! Wormshill is a small village approximately 8 miles (16 km) south of Sittingbourne and 11 miles (18 km) north of Maidstone. The villages of Frinsted and Bicknor are 2 miles (3 km) equidistant to the east and west, respectively, while Hollingbourne is 4 miles (6 km) to the south. It lays very much on the boundary with Maidstone. The village lies on an exposed high point of the North Downs, within the Kent Downs Area of Outstanding Natural Beauty. Wormshill was listed under the name *Godeselle* in the Domesday Book but is thought to be much older, its name deriving from the Anglo-Saxon god Wōden, hence Woden's Hill, a name later corrupted to Wormshill. The University of Nottingham's Institute for Name-Studies has, however, offered the suggestion that the name means a shelter for a herd of pigs. This fits nicely with the area's once heavily wooded landscape where pigs would have been kept. The village church is dedicated to St Giles. Officially recorded as being medieval in origin, parts of the church date back to the Norman era. The building is constructed from flint in the Early English style.

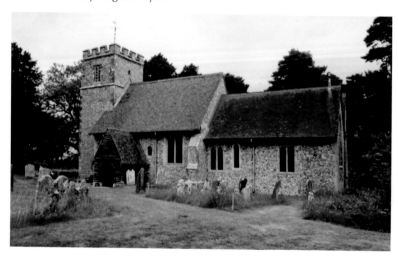

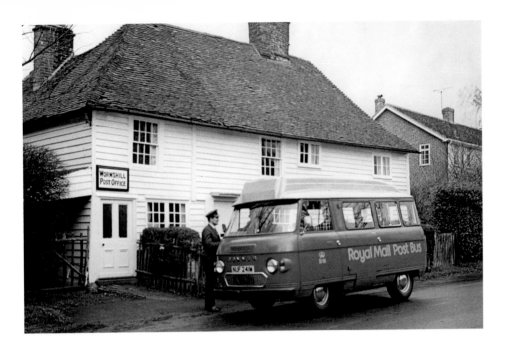

The Village Post Office

Until recent times Wormshill had one of the oldest surviving post office buildings in the UK. The original post office opened in 1847 and was run by churchwarden Tom Clements from a building next to the rectory The building, which now forms part of a Grade II* listed private dwelling, is thought to be the second-oldest surviving post office building in England with a service dating from 1847. The post office briefly moved to another location in *The Street* under the stewardship of local schoolmistress Fanny Harris (who operated the service from 1926); however, it returned to the original site in 1946 under the new sub-postmistress Irene Bugden and was run as a small general stores until it closed in 1976.

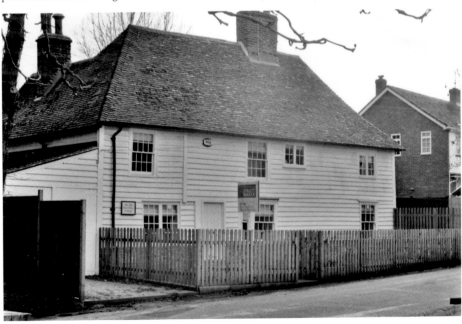

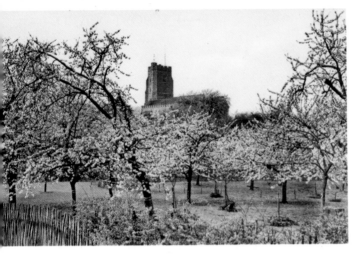

A Fluffy Cloud of Blossom
Springtime in Kent is a
magical time, with extensive
vistas of blossom as far as
the eye can see. Looking
particularly magnificent are
the towers of parish churches,
rising magnificently and
majestically from a white,
fluffy cloud of blossom.

Acknowledgements

I would like to extend my sincerest thanks and gratitude to Mrs Pat Clancy, Barry Kinnersley, John Crunden, Mrs Joyce Whitnell, Fred Atkins, Ken Washford and the *East Kent Gazette* for their help and assistance in compiling this book. I would particularly like to thank Barry Kinnersley for undertaking to photograph all the modern-day views, something I was not able to do myself due to pressure of other work. I know Barry has an eye for the detail and angles required so I felt perfectly safe in leaving this in his more than capable hands. The results fully justify my trust in him. It was not a particularly easy task to undertake as many of the scenes have changed so much in the past decades but Barry diligently tracked the location of each old postcard and here in this book is how Swale's villages look today.

I would also like to acknowledge the work of the early postcard photographers like Ash, Ramell, Shrubsole, *et al.* whose names have long been forgotten but without whom we would not have such an outstanding pictorial history of the area. Many of their scenes have not changed much in a century or more, only close inspection reveals the subtle changes that have taken place, and it is these this book seeks to show. Their work deserves special mention because through it they ensured a record for future evaluation. The craze for sending picture postcards to friends and family a century ago and more has left us with a rich legacy of a window peering into everyday life as it was then. Every part of a postcard from the picture to the stamp, the postmark, the message it contains and the address is a reminder of a time gone by and a valuable record of our social history.

Every effort has been made to authenticate the information received from various sources but sometimes time can play tricks on the memory so if any part of my text is inaccurate I sincerely apologise and will endeavour to correct it in any future editions of this book. Every reasonable effort has been made to trace and acknowledge the copyright holders of the photographs and illustrations used herein but should there be any errors or omissions or people whom I could not contact, I will be pleased to insert the appropriate acknowledgement in any future editions.

John Clancy, BA (Hons)